Color Scheme

Color

Scheme

An Irreverent History of Art and Pop Culture in Color Palettes

Edith Young

PRINCETON ARCHITECTURAL PRESS · NEW YORK

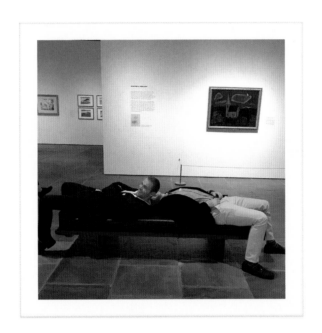

For my brother William,
and in memory of Clark Perkins,
two people I've been lucky to share
a museum bench with.

Contents

8 Foreword, Zachary Fine

11 Introduction

14 The reds of the red caps in Renaissance portraits, 1460–1535

16 **The Artist's Palette**

20 The blush of Madame de Pompadour's cheeks, 1746–63

ART HISTORY

28 **The Art History Detective**

30 The dresses worn by Velázquez's infantas

34 Frans Hals's ruff collars

Palettes

40 The pupils of the eyes in Vermeer's portraits, 1656–72

42 Caravaggio's *Boy with a Basket of Fruit*, 1593

44 The yellow bills in John James Audubon's
 The Birds of America, 1827–38

46 The blue bills in John James Audubon's
 The Birds of America, 1827–38

48 The roseate bills in John James Audubon's
 The Birds of America, 1827–38

50 The blush of Marie Antoinette's cheeks

52 Thanksgiving in America, 1825–2009

54 Seascapes, arranged along one horizon line

60 The mountaintops of the diorama paintings in
 the American Museum of Natural History

62 Helen Frankenthaler's orange color fields

64 Charles Burchfield's violets and violas

66 The stripes in Alice Neel's portraits

68 The flesh tones of Lucian Freud's ex-wives

70 Fairfield Porter's skies

CONTEMPORARY ART

74 The Typologists

Palettes

82 The artist's palette, from Anguissola to Botero
84 The blues of David Hockney's pools
86 Botero's beverages
88 The paint on Kerry James Marshall's smocks
90 The greens of the garnishes in Wayne Thiebaud's still lifes
92 Etel Adnan's suns
94 John Currin's blondes
96 The letter "E" in Mel Bochner's paintings

POP CULTURE

100 The Color Strategy

Palettes

108 Tonya Harding's figure skating costumes per competition
110 Prince's concert outfits
112 Paul Thomas Anderson's oeuvre
114 Craig Sager's suits, in chronological order over the course of his sportscasting career
116 Walt Frazier's suits, in chronological order over the course of his sportscasting career
118 Dennis Rodman's hair dye, in chronological order over the course of his NBA career
122 Title cards from the second season of *Saturday Night Live,* 1976–77
124 How Pete Davidson dresses from the waist up on Weekend Update
126 Spike Lee's eyeglasses, 1989–2020

128 CMYK VALUES
142 ACKNOWLEDGMENTS

Foreword

Zachary Fine

I am submitting my bid to have Edith Young's name added to the graying line of men in the history of color. The philosophers and scientists and dabblers—from Aristotle, Newton, and Goethe to Albers—have told us a great deal about what color is, how it is seen, and how it works. Young's contribution is different.

Color Scheme is a visually dazzling book that not only brings colors together from different places and epochs but subtly rewires our sense of sight. We are in the habit of seeing color as a kind of ornamental cloak: we adorn ourselves in blues and greens, mistakenly paint our houses in mauve, and repaint them again in beige, the fashions changing, our moods and preferences shifting. But our perception of color is affected by objects as much as our perception of objects is affected by color—it's not just a red apple but also an apple'd red. There is no color without a material substrate: a daub of gouache, a pixel, a particle. The genius of Color Scheme is that it gives color back its form, restoring time and place to the floating words—red, yellow, blue—and supplying them with history and humor.

We can find the isolated detail here changing color-wise across an artist's work (the dresses of Diego Velázquez's infantas, the flesh tones of Lucian Freud's ex-wives, the ruff collars in Frans Hals), or the variations of a color across the same item in different paintings (the reds in Renaissance caps). We can see a single thing shifting in time (Dennis Rodman's hair color morphing through the Chicago Bulls' '96 playoff run) or have a single thing compressed (Caravaggio's Boy with a Basket of Fruit in twelve colored tiles).

For André Malraux, the magic of photography was that it could bring the world of art near—Chartres Cathedral on the page, shoulder-to-shoulder with Donatello's David and the Taj Mahal. Color Scheme imagines something similar for color. Everything distilled

into its most vibrant aspect, collected and arranged. Hidden affinities throughout history, a whole system of correspondence undergirding the visible world.

Through the filter of Young's palettes, everything looks different to me now. When I pour my coffee in the morning, I am transfixed by the blue of the mug. It is suddenly more than a mug. It is a portal to a larger system of mugs. On its surface, I see the rhubarb-colored mug I bought in college, the mint-colored mug my father was partial to for many months, the lowly and graying white mug from an old diner. I see the contents of my visual life arrayed before me according to color, and it's as if I've entered the world at a secret angle.

Introduction

While a student at the Rhode Island School of Design (RISD), I went to the Cable Car Cinema in Providence one evening and saw the 2011 documentary *Diana Vreeland: The Eye Has to Travel.* The film, which orbits around Vreeland's career as a magazine editor and later as the special consultant to the Metropolitan Museum of Art's Costume Institute, recalls a grandiose passage from *D.V.*, Vreeland's 1984 autobiography: "All my life I've pursued the perfect red. I can never get painters to mix it for me. It's exactly as if I'd said, 'I want Rococo with a spot of Gothic in it and a bit of Buddhist temple'—they have *no* idea what I'm talking about. About the best red is to copy the color of a child's cap in *any* Renaissance portrait."[1]

Sitting in the dark theater, I was struck by Vreeland's idea of perfection in color. Her statement was inexact and somewhat ludicrous, though somehow charming and true, all at once. I immediately had a sense of how the idea could be both debunked and reinforced, and how this would take its visual shape in the form of a color palette, riffing off of the paint chips one might peruse at Benjamin Moore or Farrow & Ball. And so the reds of the red caps in Renaissance portraits became the first palette in this series.

From that first print, the series has expanded in its scope. While these palettes can be enjoyed for the colors alone, the ongoing research project is committed to showing viewers new ways of thinking about artists' oeuvres and larger arcs in art history. Art and art history can be a bit intimidating, and I like creating an entry point that sets the tone with a sense of irreverence. At times, these typologies of color and text pinpoint revealing themes throughout artists' careers or over time, secreting them into the viewer's brain with the Trojan Horse of humor. Other times, the palettes present a bit of a puzzle, willing the viewer to decode the pattern they see before them. For the newly initiated art enthusiast and art history buff alike, I hope the palettes feel a bit like a friend elbowing you in the rib, winking when you get the in-joke. I imagine that conceiving these palettes is the closest I'll ever get to an immersive sensation I've always wanted to emulate: that of Mario, jumping at full speed through a museum's gigantic, membranous paintings to access other dimensions in *Super Mario 64.*

The first phase of this project originated within the warm confines of art history, though over the course of a few years, the palettes expanded into a slightly more mainstream territory, when certain niche fixtures of pop culture

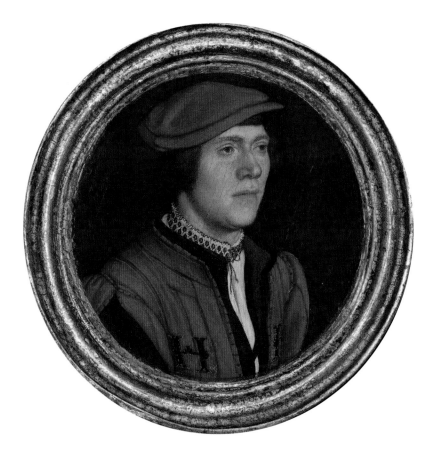

Hans Holbein the Younger (German, 1497/98–1543), *Portrait of a Man in a Red Cap*, 1532–35; oil and gold on parchment, laid down on linden. Courtesy of the Metropolitan Museum of Art, bequest of Mary Stillman Harkness, 1950.

caught my attention with the same kind of verve that paintings do. As all good things do, it started with Tonya Harding. One night, I dove deep into researching the figure skating costumes that Harding had conceptualized and sewn herself, the colors of which I then plotted in chronological order per competition. My sense of subject matter broadened again when I received a commission to create a palette of chromatic eccentricities in director Paul Thomas Anderson's films.

I continued to impose my semi-scientific approach on the nooks and crannies of pop culture that held my interest, elevating these artifacts, character traits, and perceived patterns to the same kind of aesthetic consideration I applied to art. One of my favorite instances of this is evident in a new palette made for this book, which distills the colors of legendary rebounder Dennis Rodman's hair dye in chronological order over the course of his NBA career. An artist in his own right, Rodman is the ultimate colorist, creating a spectacle by punctuating basketball arenas with his own chromatic point of view. In the thick of his career, Rodman injected an element of novelty into the game, conjuring anticipation among his audience for how he might appear at the next game and the next—it was always anybody's guess, but an aesthetic distinctly his own.

In the studios at RISD, I had the privilege of inspecting art history not only from the vantage points of art historians and professors but from practicing artists, and my exposure to that point of view informs the approach of the palettes and essays ahead. Lowering the overhead lights, cuing up a slideshow, and walking us through the works of emerging and established artists, my teachers delivered lectures that felt like X-rays of artwork, revealing the technical and conceptual framework obscured under the surface. Museums and their permanent collections can become a bit predictable, exhibiting the same canon of artists and works, and these lectures tended to stretch beyond that institutional roster, introducing us to new dimensions of the art world.

I hope this book feels a bit like sinking into a cushy auditorium chair in an art history lecture, or maybe like the revitalizing relief of a well-placed bench in a museum gallery. No matter how much you know, I also hope this book might serve as a conduit to discovering new artists or new elements of work you're already familiar with; that it piques your interest in learning more about art, artists, or art history; or that it might plant the seed of a new idea in your head—whether it's an application for a color palette, a way to dissect art already familiar to you, or a fresh way to riff on art history.

NOTE

1 Diana Vreeland, *D.V.* (Boston: Da Capo Press, 2003), 103.

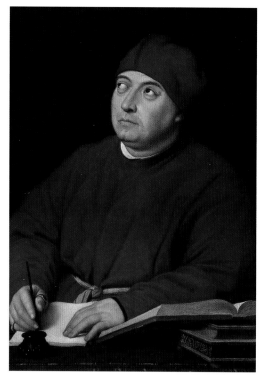

Raffaello Sanzio (Italian, 1483–1520), *Portrait of Tommaso Inghirami, known as "Phaedra,"* 1510–11; oil on panel. Courtesy of the Uffizi Gallery.

The reds of the red caps in Renaissance portraits, 1460–1535

While a student at the Rhode Island School of Design, I went to the Cable Car Cinema in Providence one evening and saw the 2011 documentary *Diana Vreeland: The Eye Has to Travel*. The film recalls a grandiose passage from *D.V.*, Vreeland's 1984 autobiography: "All my life I've pursued the perfect red. I can never get painters to mix it for me. It's exactly as if I'd said, 'I want Rococo with a spot of Gothic in it and a bit of Buddhist temple'—they have *no* idea what I'm talking about. About the best red is to copy the color of a child's cap in *any* Renaissance portrait."[1] I was struck by this inexact and somewhat-ludicrous idea of perfection in color, and immediately had a sense of how the idea could take a visual shape. And so the reds of the red caps in Renaissance portraits became the first palette in this series.

NOTE

1 Diana Vreeland, *D.V.* (Boston: Da Capo Press, 2003), 103.

A Boy in a Scarlet Cap

A Young Man in a Red Cap

An Old Man and His Grandson

Portrait of a Young Man

Portrait of a Youth

Portrait of a Man in a Red Cap

Portrait of a Young Man

Portrait of a Young Man, Bust Length, in a Red Cap

Portrait of a Woman with Red Cap

Portrait of Dr. Johannes Cuspinian

Portrait of a Young Man

Self Portrait

Portrait of a Young Man

Portrait of a Young Man in a Red Cap

Portrait of Tommaso Inghirami, known as "Phaedra"

Young Man in a Red Cap

The Duke and Duchess of Urbino

Portrait of Francesco Sforza

Portrait of a Man in a Red Cap

Portrait of an Unknown Man with Red Beret

The Artist's Palette

Few are impervious to the beauty of a color palette. What is it that makes the format just plain appealing? To decode it, I start by calculating the sum of its parts: There's color contained in rectangles, capturing a substance that is otherwise shapeless, and providing form, like water in a glass. There tends to be an interplay between several different colors and, therefore, multiple rectangles in one palette. Then there's the text, the labeling of the color that assigns meaning and sets the rectangle in a certain context. This language functions like metadata, creating another layer of distinction between the colors beyond how they're visually perceived. The act of funneling color and language into a palette takes visual data and imbues it with emotion. These colors are then placed on a "neutral" foundation (a white page, a blank wall) and given a title, whether that's "Benjamin Moore Paints" or a work of art like Walid Raad's *Secrets in the Open Sea* (1994–2004).

The phenomenon of the color palette has found new legs in the Instagram era. It's an aesthetic pleasure I'm curious to dissect: How do the gridded arrangement of squares accompanied by pithy text make color palettes visually seductive and endlessly novel during a time of rapid visual fatigue? A refillable framework with infinite potential to be recontextualized, the color palette persists.

The color palette offers a facade of order, a way in which to make sense of the world—the satisfaction of information sorted, data visualized, color interpreted—meaning assigned to abstraction. It suggests that something has been distilled to its purest form, its truest truth. More often than not, artists and designers filter these colors through a lens of optimism: a collection of colors presented in the abstract tend to evoke more levity than doom.

My initial reaction to many of the color palettes that proliferate on the internet today is that they are meaningless, empty, vapid—images that have proven only their ability to perform online and on social media channels as visual catnip or clickbait. When I push past the limits of my cynicism, I can recognize that palettes like those that parse out the color of film stills are a worthwhile means of recognizing the work of colorists, whose profession revolves around perfecting the chromatic tone and character of a film. Like a virtual version of breaking into the art director's office and rifling through their files, these color palettes deconstruct the final film, taking a stab at understanding how the art directors, production designers, and colorists cobble certain scenes and worlds together.

There's a painting in the collection of New York's Museum of Modern Art by Ellsworth Kelly called *Colors for a Large Wall* (1951), made up of sixty-four squares, some white, some black, livened up with twenty-six blocks in construction paper hues. The caption on the museum's wall argues that the painting links four processes fundamental to modernism: "the additive composition of similar elements (each square is painted separately), the use of chance (each square is arranged randomly), the idea of the readymade (each color was taken from the French craft paper Kelly used to produce the collage on which the painting is based), and the allover grid of its composition." The museum's anonymous voice asserts that this is "a painting in which no aspect of its appearance has been determined by the artist's personal choices." This refusal to acknowledge the role of the artist's subjectivity hints at what may make this painting appeal to a broader audience. While there are elements of Kelly's preference that informed the work (the kind of craft paper he picked out at the store, for one), the painting is presented without editorialization. The same applies to the color palette. Borrowing the authoritative language of a brand like Pantone or Benjamin Moore or Farrow & Ball, the palette's gridded format has a matter-of-factness about it, presenting its data almost like a graph, with an air of objectivity rather than of opinion or tastes.

The color palette is not a territory I can claim as my own. There's a whole bench of venerated artists who precede me in this department: John Baldessari, Barbara Bloom, Spencer Finch, Byron Kim, and Walid Raad among them. Although these artists all use the gridded color palette as a basis for imbuing color with meaning, they each take an entirely different tack with the material.

The visual language of the color palette has recurred in Finch's work throughout his career. In one early instance, Finch made one hundred pastel drawings, each a large oval in a shade of pink. Arranged in a horizontal row that continues across four walls of a room, Finch labeled the drawings with the installation's title followed by the serial number of each pink gesture, such as *Trying to Remember the Color of Jackie Kennedy's Pillbox Hat 43*. This 1994 work attempts to recall the iconography surrounding President John F. Kennedy's assassination while struggling with the murkiness of memory when remembering the event. These drawings are of the same mind as Finch's later, most well-known piece, an installation in New York's National September 11 Memorial & Museum entitled *Trying to Remember the Color of the Sky on That September Morning* (2014).

As an artist, Finch is fascinated by the intersection of light, color, and memory, and his 2013 installation *Back to Kansas* functions as a prime example of the way he examines this relationship. The piece comprises seventy squares, each a color drawn from the 1939 film *The Wizard of Oz*. *Back to Kansas* has taken multiple forms—as an acrylic study, as a color aquatint and chine-collé print, as a freestanding sculpture in the garden of the Crystal Bridges Museum of American Art, and as a painting in the San Francisco Museum of Modern Art. In Finch's acrylic study, one can corroborate both the color's

source (yellow brick road, witch's broom, ruby slippers) and their corresponding time stamps in the movie (19:45, 29:16, 30:00), thanks to the captions below each swatch. Built to the scale of a movie theater's screen, the larger installations are confined to the film's original aspect ratio and exposed to the natural cycles of daylight and nightfall. At dusk, the colors mute, invoking the film's own interplay between Technicolor and black and white.

When I asked Finch what he thought it was about the color palette or chart as a form that makes it so visually appealing, he was straightforward: "Color is a delight—I think it's as simple as that."[1] He had been introduced to artists who subvert the conventional color chart—Kelly, Gerhard Richter, and Josef Albers—as a student, though subversion isn't quite the right word to describe Finch's practice now. While he has been using a tool called the colorimeter—a light-sensitive instrument that measures how much color is absorbed by an object or substance—since 2001, his work hasn't hinged upon a belief in its precision. "I think I am more interested in the absurdity of trying to quantify something that is ultimately very subjective," says Finch. "I really appreciate the scientific method as a form of inquiry, but it doesn't yield much when applied to understanding color." From the beginning, Finch has been opposed to the idea of an objective truth in art, and instead focuses on subjectivity and relativity: "This is why certain strategies, such as seriality and multiplicity, appear so often in my practice. I guess I am having an argument with the truth, or maybe even, as Robert Frost said, a 'lover's quarrel.'"[2]

Finch came of age at the same time as another like-minded artist on my color chart radar, Byron Kim. Of the through lines he identifies between Kim's work and his own, Finch told me: "I think we both have an ambivalent relationship to abstraction and feel that art should have some connection to the world."[3]

In Kim's banner installation *Synecdoche* (1991–ongoing), he displays over four-hundred 8 × 10–inch panels of various skin tones on a massive grid. Each panel represents a friend, family member, artist, or stranger, whose coloring Kim recorded with oil paint mixed with wax. The work, which premiered at the 1993 Whitney Biennial, is displayed alongside a legend that decodes the panels. The corresponding captions for these colors are the names of the subjects rather than chromatic names for the subjects' epidermal hues. Some of those names, like Chuck Close, William Wegman, Glenn Ligon, Lorna Simpson, and Kiki Smith, may ring familiar to museumgoers.

Another work of Kim's poses something of a counterpoint to *Synecdoche*. By all accounts, *Emmett at Twelve Months, #3* (1994) looks like a smaller-scale version of *Synecdoche*, but whereas *Synecdoche* represents one person per canvas, this portrait conjures the essence of one person with twenty-five panels. Here, Kim transcends skin tone and renders his son Emmett more multidimensionally by painting panels that account for the shades of his pupils, the whites of his eyes, the hues of his hair, and, perhaps, some more ambiguous sources of color, like an elbow, a birthmark, or the arch of a foot.

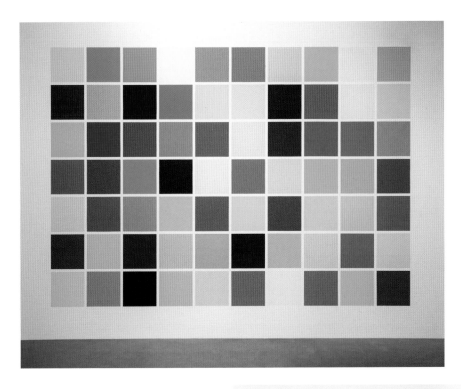

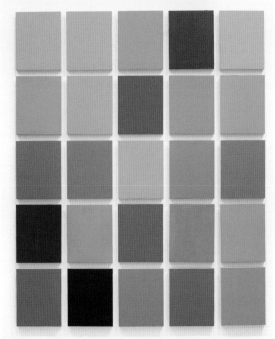

above
Spencer Finch (American, 1962–),
Back To Kansas, 2013; wall painting and
natural light. Courtesy of the artist.

right
Byron Kim (American, 1961–),
Synecdoche, 1991–2018; wax and oil
on panel. © Byron Kim 2020, image
courtesy of the artist and James Cohan,
New York. Collection of Tate, London.

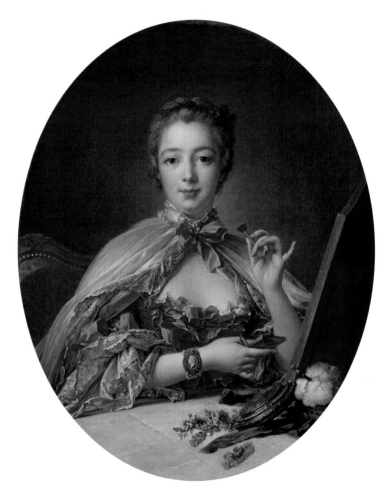

François Boucher (French, 1703–1770), *Jeanne-Antoinette Poisson, Marquise de Pompadour*, 1750; oil on canvas. Courtesy of Harvard Art Museums/Fogg Museum, bequest of Charles E. Dunlap.

The blush of Madame de Pompadour's cheeks, 1746–63

I became entranced by François Boucher's portrait of Madame de Pompadour when I first encountered her in Harvard's Fogg Museum, and quickly discovered that Pompadour had left her mark all over the history of art.

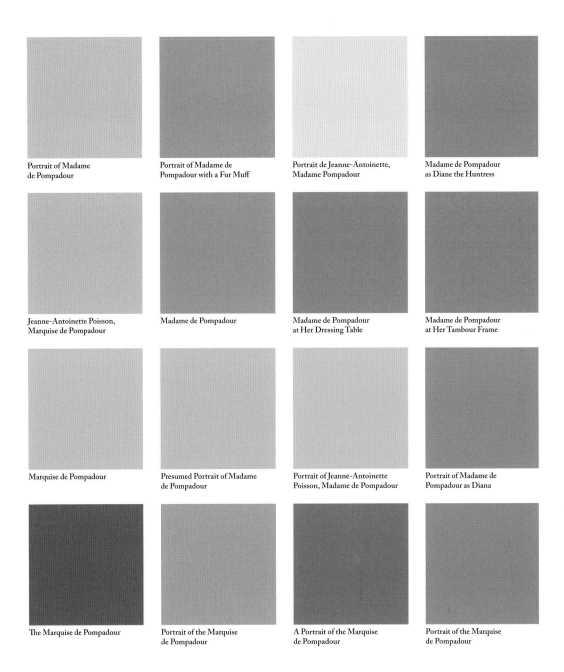

Portrait of Madame
de Pompadour

Portrait of Madame de
Pompadour with a Fur Muff

Portrait de Jeanne-Antoinette,
Madame Pompadour

Madame de Pompadour
as Diane the Huntress

Jeanne-Antoinette Poisson,
Marquise de Pompadour

Madame de Pompadour

Madame de Pompadour
at Her Dressing Table

Madame de Pompadour
at Her Tambour Frame

Marquise de Pompadour

Presumed Portrait of Madame
de Pompadour

Portrait of Jeanne-Antoinette
Poisson, Madame de Pompadour

Portrait of Madame de
Pompadour as Diana

The Marquise de Pompadour

Portrait of the Marquise
de Pompadour

A Portrait of the Marquise
de Pompadour

Portrait of the Marquise
de Pompadour

Raad understands the lure of color and its potential for deception. The story behind Raad's *Secrets in the Open Sea*, each of the six prints a rich rectangle of blue, hides in plain sight on the tiny black-and-white images punctuating the right-hand corners of the prints. I saw the Lebanese artist's series on exhibition at Boston's Institute of Contemporary Art as part of a larger survey of his career in 2016. In much of his work, Raad fabricates fictional but believable narratives (I've been hoodwinked by Raad before), and this piece is no exception. The exhibition copy posits that these blue photographs were found in the rubble of Beirut in 1992, and following further lab analysis, an imaginary foundation discovered black-and-white negatives embedded in the fields of blue like pentimento, a visible trace of an earlier work concealed beneath the surface. The photographs allegedly depict groups of women and men who had "drowned, died, or were found dead in the Mediterranean between 1975 and 1991." Here, Raad follows the conventions of a color palette, qualifying a color with a black-and-white negative as its caption or form of metadata. He manages to infiltrate the color palette as a medium, one that often appears unemotional and operates on a surface level, by giving the superficial-seeming form a darker underbelly, inviting an ominous, morbid narrative to loom underneath the lushly saturated surface. With 44 × 69–inch plates of color, Raad far exceeds the scale of the local hardware store's paint chip. Standing in front of one of these prints, my whole field of vision is swallowed in a sea of electrifying blue.

In an exhibition staged at Sprüth Magers London in 2006, the late conceptual artist John Baldessari showed sixteen pieces, nine of which took the form of the color palette. Baldessari entitled the exhibition *Prima Facie*, Latin for "at first sight," focusing his attention on the knee-jerk human instinct to construct meaning, especially when viewing language and color in tandem. In a diptych format, he placed the words "PURE JOY" next to a block of primary yellow. In another print from the same series, Baldessari typeset the word "LUSCIOUS" next to a block of lilac. Next to a gauzy, nearly imperceptible cool gray, there's "MARILYN'S DRESS." The viewer's active participation in perceiving these pieces completes the show, as Baldessari aimed to demonstrate the way a person has been culturally and psychologically programmed to interpret certain visual phenomena. In *Prima Facie (Fifth State): Warm Brownie/American Cheese/Carrot Stick/Black Bean Soup/Perky Peach/Leek* (2006), Baldessari pairs six colors with the names of six foods in a grid, chiding the predictable perception of color and its associations.

The Barbara Bloom Color Chart (1998) has pride of place on the cover of Bloom's 2007 monograph, *The Collections of Barbara Bloom*, a retrospective of the artist's work. In it, Bloom writes that she "loved color charts because of the odd way they brought together the wholly abstract (a rectangle of color) and the delimiting power of language (a name)."[4] In her custom color chart, Bloom assigns arbitrary names to various colors ("Enzyme" to an acid yellow, "Lolita" to a lavender, "Ringo" to an orangey red, "as if" to a chartreuse, and

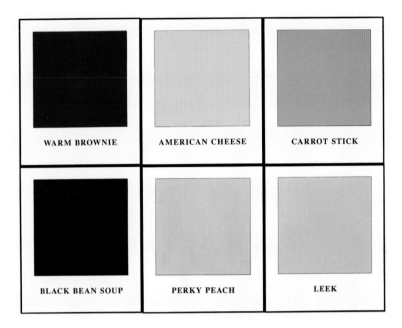

WARM BROWNIE	AMERICAN CHEESE	CARROT STICK
BLACK BEAN SOUP	PERKY PEACH	LEEK

John Baldessari (American, 1931–2020), *Prima Facie (Fifth State): Warm Brownie/American Cheese/Carrot Stick/Black Bean Soup/Perky Peach/Leek*, 2006; six ink-jet prints with latex paint on canvas. © John Baldessari, 2006. Courtesy of the Estate of John Baldessari, © 2021

"Miranda Rights" to a pale apricot), poking fun at the eccentricity of paint companies' naming practices.

Collecting plays a significant role in Bloom's practice, and she devotes a spread in her monograph to the found color palettes she's amassed over the years, including but not limited to the lyrics from "Reno Dakota," a Magnetic Fields song ("It's making me blue / Pantone 292"), Chinese ceramics covered in rectangles of sample glaze colors, a film still from Jean-Luc Godard's *La Chinoise* (1967) of a shot that tracks across color samples from a paint chart, and a carpet she snatched up at a rug emporium in Berlin (a color sampler for wholesalers that had accidentally found its way into a stack of Oriental carpets).

Like Bloom, I've been collecting instances of the color palette as I've happened upon them. My collection includes:

- A 1973 Jeep flyer for exterior color options ("Avocado Mist," "Jetset Blue," "Omaha Orange," "Butterscotch Gold")
- T-shirts by New York designer Recho Omondi and Tate Modern (categorizing the visible light spectrum and the colors of London, respectively)
- Paint-dolloped pajamas designed by decoupage artist John Derian for Andy Spade's pajama brand, Sleepy Jones

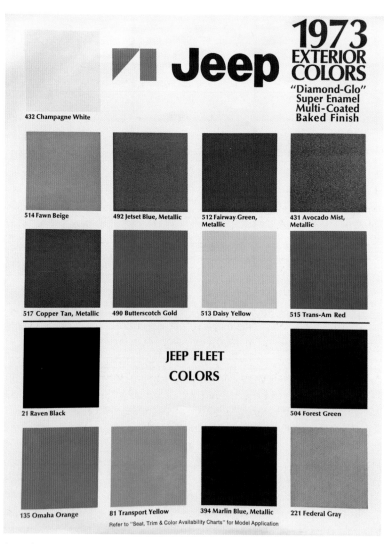

Jeep advertisement, 1973. Courtesy of the author.

- A postcard by Roz Chast of a New York palette, with schmutz, subway tile, and espresso all accounted for
- The album cover of jazz saxophonist Tina Brooks's 1960 record *True Blue*
- A "Rock and Roll Paints" palette jostled loose from a 1970s *Scholastic* magazine (attributed to one Pat Arthur, the shades of green including "Elvis Parsley," "Al Green," and "Limon & Garfunkel")
- Fashion designer Todd Oldham's "Rubik's Cube" textile design from his Spring 1996 collection, inspired by a dog-eared copy of a secondhand Pantone book that he and his studio cut up and then assembled into a pattern (arranging 1,400 individual squares of color into a grid, Oldham's studio made it possible to avoid a single color repeat on a garment)

Design world mythology attributes the beginnings of a maxim—with dubious credibility—to twentieth-century designer and art director Paul Rand, and it's morphed into an old art school joke over the years: "If you can't make it good, make it big. If it doesn't look good big, make it red. If you want it to sell, make it shiny." (In the case of a color palette, you can at least make it big and red, if not shiny.) Around the same time I heard that joke, I considered the art that engrossed me and determined its commonalities, in some cases its nonnegotiables. The art I love possesses an element of surprise, a sense of humor, an aura of beauty.

Sometimes I visit a museum and leave feeling like I've been told that beauty is anathema, or a bygone value, never to be seen again. The suppleness of a color palette offers a counterpoint. I grow accustomed to the colors of my own ecosystem. They don't change much day to day, week by week. To be awash in a palette feels like taking a micro-vacation to a new color scheme, organizing principle, or, better yet, the artist's brain. The color palette is a reminder of the other colors out there and the infinite possibilities afoot.

The color palette has sunk its beautiful teeth into the history of art. The skeleton of the gridded color chart persists, a form awaiting the content—emotional, intellectual, critical, chromatic—and whims of an artist, and will be so long as painters are painting and Pantone crowns a color of the year.

NOTES

1 Spencer Finch, email correspondence with the author, July 9, 2020.

2 Finch, July 9, 2020.

3 Finch, July 9, 2020.

4 Barbara Bloom, Dave Hickey, and Susan Tallman, *The Collections of Barbara Bloom* (Göttingen, Germany: Steidl, 2007), 46.

ART HISTORY

The Art History Detective

'll confess one of my glaring personality flaws: I've never been terribly comfortable with international travel. Recently, I've devised an incentive structure in the hopes of moving my homebody needle. My plan is to map out all of the foreign museums I'd like to visit, with the objective of seeing centuries-old pieces like the *Ghent Altarpiece* (1432) by the brothers Hubert and Jan van Eyck, Jan van Eyck's *Arnolfini Portrait* (1434), Hans Holbein the Younger's *The Ambassadors* (1533), Masaccio's fresco *Expulsion from the Garden of Eden* (1426–27), and Diego Velázquez's *Las Meninas* (1656) in person. I have, however, been able to see some art made in reference to these great works on more local shores: respectively, photographer Duane Michals's *The Annunciation* (1969), Fernando Botero's *The Arnolfini (after Van Eyck)* (1997), Kerry James Marshall's *School of Beauty, School of Culture* (2012), and David Hockney's *Expulsion from the Garden of Eden* (2002), a pastel watercolor across six sheets of paper, somehow still throbbing with despair.

In the first art history survey class I took, my teacher threaded throughout his syllabus the idea that certain artists work, and perhaps see themselves, as a part of an art historical lineage. Viewing artists' careers through this lens often yields compelling or curious observations. Each artist is of course going to differ in the way they relate, and choose to engage with, the history of art. Some of these artists work in reverence of their predecessors, while others use the familiar imagery to counter the original message.

The artist Walton Ford holds court as a favorite of mine. He often wrestles with his relationship to the sensibilities of nineteenth-century natural history artists, like the celebrated John James Audubon, though Ford marries impeccable technical skill with an awe-inspiring ability for compressing an inventive narrative—informed by historical research—into a single frame. His *American Flamingo* from 1992 seems to capture the moment directly after the one depicted in Audubon's iconic plate of the American Flamingo dating back to 1838. In Ford's interpretation, the elegant, lanky bird has been shot by a rifle. Legs akimbo, blood spurting, feathers flying, it's almost as if the bird hasn't been hunted but has instead slipped on a banana peel.

When artists treat art history as a kind of modeling clay for a piece, the original artwork's origin story often serves as a kind of legend for understanding what the contemporary artist is expressing now. It is the art of the reference, the art of subtext. These works can operate on a plane where the reference

isn't understood, though the experience is enriched when it is. (The seeds of my intrigue with subtext were likely planted by a book I read as a kid, *Art Fraud Detective: Spot the Difference, Solve the Crime!* (2000) by Anna Nilsen, which first oriented my relationship with paintings. Now I always feel tasked with finding the clues within works that share a visual language). Perhaps not everyone is keen on the gamification of their art history knowledge, but I've found it to be like a key that unlocks meaning in the imagery around me, whether that's in a gallery or a Gucci advertisement. These nods, references, and iterations treat the history of art like a family heirloom, carefully handed down from generation to generation, sometimes continuing or unmuffling a conversation, other times rewriting, recontextualizing, or reclaiming a narrative that had been excluded from the cisgendered white male canon.

I can see how a degree of mimicry might be beneficial to the burgeoning artist—I certainly drew some semblance of Velázquez's *Las Meninas* in a required figure-drawing course, attempting to imitate the artist's more muscular motions to develop a new understanding of his compositional genius. As someone whose skill set skewed more lens-based and computer-centric, I talked myself into enduring that charcoal-covered year of eight-hour studio classes by considering how the experience narrowed the gap between the artists I studied in my survey courses and myself, despite how much my canvases left to be desired compared with theirs. I reasoned that all of this time standing at the easel was a bit like walking a mile in their shoes, and it would be instructive as a student of art history to bear witness to something resembling their bodily experience of putting pen to paper.

One way to rationalize it was that if Pablo Picasso did it, so should I. Over the course of four months, from August to December of 1957, Picasso painted about fifty variations of *Las Meninas*—some explored the whole composition while others zoomed in on Velázquez's infantas. Picasso iterated on what is often considered the greatest painting in history, rendering his series in varying sensibilities but all identifiable as Picasso's hand. Undertaking this project at the age of seventy-six indicated that while he was up to the task, he also might still have something new to glean from a close investigation of the master. As with *The Maids of Honor (Las Meninas, after Velázquez)*, the first and largest composition in the series, Picasso includes many recognizable elements from Velázquez's original but makes it his own, converting the painting's palette into grayscale values and replacing Velázquez's mastiff with Picasso's own dachshund, Lump.[1] From then on, Lump emerges as a recurring figure in this series, though at times his canine form looks more like that of a cat or a small alligator.

Viewing reproductions of these works in succession has a cinematic quality. Some shots are close-ups, occasionally giving the impression of an infanta's gloomy inner world, and some shots are wide, showing how the members of the group relate to each other, but all reference the same scene, perpetually on the precipice of unfolding. Picasso eventually gave the entirety

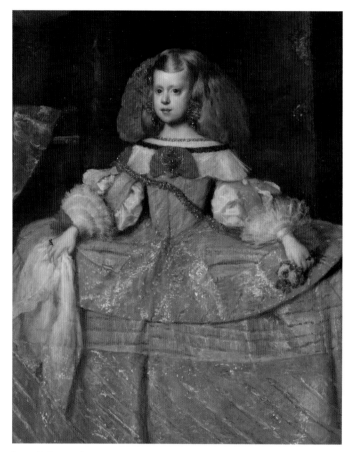

Diego Velázquez (Spanish, 1599–1660), *Infanta Margarita Teresa*, 1651–73; oil on canvas. Courtesy of KHM-Museumsverband.

The dresses worn by Velázquez's infantas

Who wouldn't want to dress like one of Diego Velázquez's infantas, if given the choice?

Infanta Margarita Teresa
in a Blue Dress, 1659

Infanta Margarita Teresa
in a Pink Dress, 1660

Portrait of the Infanta María
Theresa of Spain, 1651–53

María Teresa, Infanta of Spain,
1651–54

La infanta Margarita, 1653

La infanta Margarita, 1656

La infanta María Teresa, 1648

Las Meninas, 1656

of his finished series to the Museu Picasso of Barcelona in 1968.[2] Picasso having his way with Velázquez's seminal work only further solidified *Las Meninas* not only as a transcendent work but also as a trope or as an icon, ripe for the riffing.

In the introduction of his review of the show *Velázquez* at the Metropolitan Museum of Art in 1989, art critic Peter Schjeldahl aptly summarized the painter's place in, and his specter over, the history of art: "Diego Velázquez (1599–1660) was as good at oil painting as anyone has been at anything. When Édouard Manet, discovering him at the Prado in Madrid in 1865, said that he wondered why others, including himself, bothered, he expressed an enduring thought: painting has been done, and Velázquez did it. That was a watershed historical moment. Modern art was born when Manet saw Velázquez and despaired."[3] Given that praise, it won't be all that surprising to hear that Harvard's Fogg Museum houses a few etchings by Manet, who in 1862 recreated the master's portraits of the Infanta Margarita and King Philip IV of Spain. Manet was always bettering his own work by poking around art history. Most notably, he drew from Titian's *Venus of Urbino* (1538) when painting his controversial reclining nude *Olympia* (1863), in which the similarity of the Parisian sex worker's pose to Titian's model is striking (supposedly because composition was one of Manet's primary weaknesses).

As with anything on the receiving end of so much hype, it's natural, and often rewarding, to dig into what it is that makes Velázquez far and away the best, most transfixing, most imitable of all the painters. There is physical evidence of this wonder in Picasso's series, in Manet's etchings, and in the more recent explorations of the artist's paintings.

Velázquez's career as a court painter created fodder for centuries of artists succeeding him, seeking new forms and relevance in their reinterpretations. I first encountered the work of Akio Takamori, a Seattle-based ceramic artist from Japan, when a curator had installed a two-and-half-foot-tall piece of his, *Alice in a Black Dress* (2009), to stoically overlook the shelves of the Boston Athenaeum library. Giving Alice a once-over, I felt the satisfaction of someone in on the joke—it struck me that Takamori had sampled Alice's dress and pose from Velázquez's *Portrait of Mariana of Austria*, circa 1653. It turned out the sculpture also made reference to a few other women, caught in the freeze-frame of their coming-of-age: the piece's namesake stems from Lewis Carroll's 1865 book *Alice's Adventures in Wonderland*, and the sculpture wears the brioche-round hairstyle of a Tang Dynasty courtesan.[4] Melding these references together in stoneware clay, Takamori compresses time, geography, and culture to create someone—a biological impossibility of far-flung references—on the cusp of adulthood.

Then there is the issue of Velázquez's *Portrait of Pope Innocent X* (1650), the more recent interpretations of which have been vehicles of either immense darkness or immense light. Francis Bacon's series of existential popes has been polarizing viewers since the mid-twentieth century. In these works,

Bacon burrows into Velázquez's composition, hits the nerve, and unearths the international sign for inner turmoil, manifest on one's face. If you've encountered any of Bacon's agonizing paintings in person, you might be surprised to hear that he was a successful interior designer at the age of twenty.[5] (And the mind wanders…what on earth could those rooms of his design have looked like?)

On the flip side, contemporary artist Spencer Finch saw the "amazing *Portrait of Pope Innocent X* in Rome" and let some of its heaviness out with his 2011 series of paintings *Red (After Velázquez)*. Small drips of red paint speckle across the canvas, looking almost like petals, or price stickers, or droplets of blood. Together, the circular splatters of paint form a sort of concrete poem, suggesting the contours of the red garment as it drapes across the pope in Velázquez's original portrait. After examining the painting closely in person, Finch mixed twenty-one shades of red and applied them like a topographical and celebratory study of the sheeny fabric—where it's smooth, where it's in shadow, and where it buckles.

Another tentpole in the scheme of art historical homages is the representation of Madame de Pompadour, the mistress and friend of King Louis XV of France who found lodging at Versailles, finagled the title "Marquise de Pompadour," aggregated power in the court over time, and eventually meddled in foreign policy, causing her short-term popularity and long-term repute among the French to take a nosedive.[6] I could see how the king might have been seduced by Pompadour when I first laid eyes on her at Harvard's Fogg Museum. In François Boucher's portrait, Pompadour sits at her dressing table. It's a masterwork of a restrained palette: her porcelain skin; gray eyes that match the color of her hair; the rosy blush she's applying that matches her lips, cheeks, and the ribbons cinching her dress together; and the cornflower-blue flowers in her hair echoing the ribbon askew on the table. One hand holds the makeup brush, and Boucher catches this blush-applying hand in the act of spreading more pink into the scene, painting within the painting. Pompadour's pinky finger points skyward, if a little northeast. Boucher etched his signature right over her shoulder, as if signing a baseball card. This is one of sixteen portraits of Madame de Pompadour that I've come across, though I find this one the most arresting.

Something about her appearance or the story of her strange existence captivates artists too. Henri Matisse produced two lithographs entitled *Madame de Pompadour* in the 1950s. The first one shows an inky outline of her face festooned with colorful, cut-paper-collage bits, angular flowers and shapes arranged to give the impression of jewelry. Matisse designed it as part of the publicity for the Bal de l'École Des Arts Décoratifs (Annual Ball of the School of Decorative Arts), a fundraising banquet held at the Pavilion Marsan at the Louvre.[7] The other lithograph from 1955 is much simpler; it reads as a brisk pencil portrait of Pompadour's face, executed with the flick of a wrist in about twenty-two lines total.

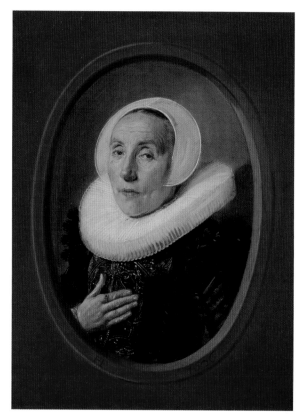

Frans Hals (Dutch, 1582/83–1666), *Anna van der Aar* (born 1576/77, died after 1626), 1626; oil on wood. Courtesy of the Metropolitan Museum of Art, H. O. Havemeyer Collection, bequest of Mrs. H. O. Havemeyer, 1929.

Frans Hals's ruff collars

I'm drawn to Hals's paintings because of the way he sometimes depicts his subjects with an air of mischief or whimsy, his sitters' levity and uninhibitedness making the seventeenth century all the more relatable. Hals continues to capture the modern imagination; Dutch photographer Hendrik Kerstens has been documenting his daughter Paula since 1995 in winking reference to Golden Age painters like Hals. In his 2011 portrait *Doily*, Kerstens photographs his daughter wearing a ream of doilies around her neck, with an austere posture and three-quarter view akin to Anna van der Aar's above.

Anna van der Aar, 1626

Portrait of an Elderly Man, Heer Bodolphe, 1643

Portrait of an Old Woman, 1633

Portrait of a Couple, 1622

Portrait of a Gentleman, Aged 37, 1637

Portrait of a Lady, Aged 36, 1637

Portrait of a Lady, 1627

Portrait of a Man in His Thirties, 1633

Portrait of a Woman (Marie Larp?), 1635–38

Portrait of a Woman in a White Ruff, 1640

Portrait of a Woman, 1635

Portrait of a Woman, Probably Aeltje Dircksdr. Pater, 1638

Portrait of an Elderly Lady, 1633

Portrait of an Elderly Man, 1627–30

Catharina Hooft and Her Nurse, 1620

Portrait of Mrs. Bodolphe, 1643

Helen Frankenthaler, too, editioned lithographs of the woman, with the title *Madame du Pompadour (H. 170)*, made up of sixty prints and fourteen artist's proofs, dated 1985–90.[8] The pale, uneasy color palette and frenzied composition evoke Pompadour's renegade spirit. What do these artists see in the symbol of Madame de Pompadour? A cautionary tale? A story of women's empowerment? The face of triviality, of indulgence, of excess (years before Marie Antoinette would come onto the scene)?

Cindy Sherman also found a muse in the mythology of Madame de Pompadour. In the late eighties, Sherman worked with Limoges, a French manufacturer, which had the casts of an objet d'art Madame de Pompadour had designed in her heyday. The artist revived a Pompadour-designed tureen and then photographed herself dressed as an approximation of Pompadour, later silk-screening the image onto the tureen's porcelain.[9] This project proved fruitful for the artist, and ultimately inspired Sherman's extensive, large-scale series *History Portraits* (1989–90). For one four-foot-tall photograph, entitled *Untitled (#193)*, the artist poses in a period-appropriate white wig and a gauzy tiered gown, fanning herself. Sherman's sense of humor juts out in the lower right-hand corner of the frame: "I thought, 'What if she's this beautiful powdered, wigged woman but then she's got these big feet sticking out?'"[10] Would Madame de Pompadour believe the projects and foot-oriented high jinks she spurred centuries after her death?

When I went to *Kerry James Marshall: Mastry* at the Met Breuer in December 2016, an ingenious element of his 2012 painting *School of Beauty, School of Culture* stuck with me most. At eight feet tall and thirteen feet wide, this painting of a beauty salon engulfs you. In the foreground, there's a floating head larger than the two toddlers who flank the face, optically warped but solid enough to cast a shadow on the floor. My eyes are able to translate or correct the image in an instant, identifying the face as Disney's Aurora, the Sleeping Beauty, though I haven't seen the animated movie in years. (Given the distortion, you would likely perceive her face as normally proportioned by standing at an extreme angle to the left of the painting.) I'm also able to identify, based on the rough placement of this eerie artifact, that by including a compromised Aurora here, Marshall nods to *The Ambassadors* by Hans Holbein the Younger, wherein a skull is distorted in nearly the exact same way.

In an exhibition catalogue that coincided with Marshall's exhibition at the David Zwirner Gallery in 2018, writer Hal Foster unpacks Marshall's litany of references in this one painting: "*School of Beauty* alludes to *Las Meninas* as well as *The Ambassadors* by Hans Holbein; in addition, its playful title evokes *The School of Athens* (1509–11), by Raphael, and its mirrored salon call ups *A Bar at the Folies-Bergère* (1882), by Manet."[11] Foster invokes a rule of thumb from the nineteenth-century French author Charles Baudelaire when pinpointing the tact with which Marshall employs the "not overly citational" art historical reference: "In this respect Marshall follows the advice of Baudelaire, who argued that painting can serve as the 'mnemotechny of the beautiful' as long as

its art-historical references are mostly subtextual in the work and subliminal in the viewer." Foster also references artist and writer Jordan Kantor's observations regarding the way in which Marshall handles his role in the broad sweep of art history, quoting Kantor: "It is a complex program of reference and amendment, which serves not only to position Marshall within an august lineage but also to read the history of art in light of its blind spots."[12]

Another transcendent painter of contemporary scenes, Salman Toor paints crowded bars, East Village apartments, and stoops in Fort Greene, Brooklyn, glimpsing into the imagined interactions of young, queer Brown men, with ties to both New York City and South Asia. A Pakistan-born and New York–based painter, Toor avoids the too-literal referential style Baudelaire warned against and has rather seamlessly ingrained his academic sense of art history into his pictures. Considering the tactility of his unvarnished brushstrokes and the way his figures relate to each other, I feel like I'm observing the present from a remove, years in the future, as if it's already been fossilized into cultural artifact. Toor imbues his work with both the weightiness of history painting and the tenderness of personal experience.

Toor does something I've only ever otherwise seen standing breathlessly in front of an 1884 John Singer Sargent painting, *A Dinner Table at Night*. The contemporary artist paints space bathed in dim interior light as if the canvas is photographic film, exposed at just the right ultra-sensitive calibration of the widest aperture and the graniest negative. Somehow, he recreates the sensation of the human eye adjusting to the ambiance of a low-lit room, and so it

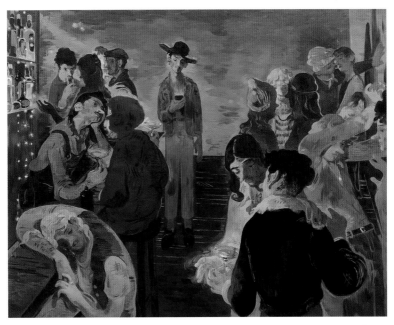

Salman Toor (Pakistani, 1983), *Bar Boy*, 2019; oil on plywood. © Salman Toor, image courtesy of the artist and Luhring Augustine, New York.

feels like a bar or an apartment I've stayed up late in before. His brushstrokes look more absorbent and less like artifice.

When I asked if or how he considers his practice to be informed by art history, Toor told me he grew up looking at works by both Indian and European artists, "images of Mughal princes and faux-folk images of village women in small tops carrying water, along with prints by Thomas Gainsborough and Peter Lely," two artists working in Britain in the seventeenth and eighteenth centuries.[13]

Toor considers these works as entry points into the fantastical escapism opportunities conjured by art. He continued his quest at Ohio Wesleyan University: "In my art history classes, I learned about the grimy peasants in paintings by David Teniers the Younger and Pieter Breugel the Elder, the dark-skinned servants in Dutch genre paintings, the steely refinement of an Anthony van Dyck subject, the sordid nightlife of Impressionist Paris. Within these were ways of looking at the relationship between the rich and the poor, ways of portraying foreignness, race, power, dignity, exoticism, difference. By continuing to paint, I feel I'm constantly redefining my relationship to this material that I never get tired of."

Toor sees himself as part of a multiethnic generation of painters in the United States who are "taking on art history to update, critique, and tweak it, to write ourselves into its rich story," crediting art history with having formed his imaginary map of the world, conquests, migrations, ideas of civilization, foreignness, and fashion. "I like seeing the thread of the past in the present," Toor says, and nowhere is this more evident than in his paintings. Informed by traditional iconography, Toor's work sets forth one example of how to paint a distinctly twenty-first-century canvas—grappling with the best and worst elements of the canon while iterating on art history as a subject matter in and of itself.

NOTES

1 Alan Riding, "Picasso's Other Muse, of the Dachshund Kind," *New York Times*, August 26, 2006, https://www.nytimes.com/2006/08/26/arts/design/26lump.html.

2 "Picasso Black and White: Comparative Works," Guggenheim, accessed November 23, 2020, http://web.guggenheim.org/exhibitions/picasso/artworks/maids_of_honor.

3 Peter Schjeldahl and Jarrett Earnest, *Hot, Cold, Heavy, Light: 100 Art Writings, 1988–2018* (New York: Abrams Press, 2020), 29.

4 "Alice/Venus," Akio Takamori, accessed November 23, 2020, http://akiotakamori.com/work/alicevenus/about-alicevenus/.

5 Schjeldahl and Earnest, *Hot, Cold, Heavy, Light*, 152.

6 "The Real Madame de Pompadour," The National Gallery, accessed February 11, 2021, https://www.nationalgallery.org.uk/paintings/learn-about-art/paintings-in-depth/the-real-madame-de-pompadour?viewPage=6.

7 "Madame de Pompadour," LACMA Collections, accessed February 11, 2021, https://collections.lacma.org/node/234040.

8 "Helen Frankenthaler, Madame du Pompadour (H. 170)," Christie's, accessed November 23, 2020, https://www.christies.com/lot/lot-helen-frankenthaler-madame-du-pompadour-h-170-1341676.

9 "Tureen with Cover and Under Plate, 'Madame De Pompadour (née Poisson) Pattern,'" Brooklyn Museum, accessed November 23, 2020, https://www.brooklynmuseum.org/opencollection/objects/188697.

10 "It Began with Madame de Pompadour: Interview with Cindy Sherman," Art21, accessed November 23, 2020, https://art21.org/read/cindy-sherman-it-began-with-madame-de-pompadour/.

11 Hal Foster, "Underpainting a Real Allegory," in *Kerry James Marshall: History of Painting* (New York: David Zwirner Books, 2019), 27.

12 Jordan Kantor, "Kerry James Marshall," *Artforum International*, January 1, 2011, https://www.artforum.com/print/reviews/201101/kerry-james-marshall-27056.

13 Salman Toor, email correspondence with the author, August 4, 2020.

The pupils of the eyes in Vermeer's portraits, 1656–72

The pupils of Johannes Vermeer's subjects may surprise you—rather than black, they're rendered in inky olive tones.

Allegory of the Catholic Faith

A Lady Writing

A Young Woman Seated at a Virginal

Girl with a Flute

Girl with a Pearl Earring

Girl with the Red Hat

Woman with a Lute

Young Woman Seated at a Virginal

Officer and Laughing Girl

Young Woman with a Pearl Necklace

The Guitar Player

The Milkmaid

The Procuress

Girl Interrupted at Her Music

Study of a Young Woman

Woman with a Water Jug

Caravaggio's *Boy with a Basket of Fruit*, 1593

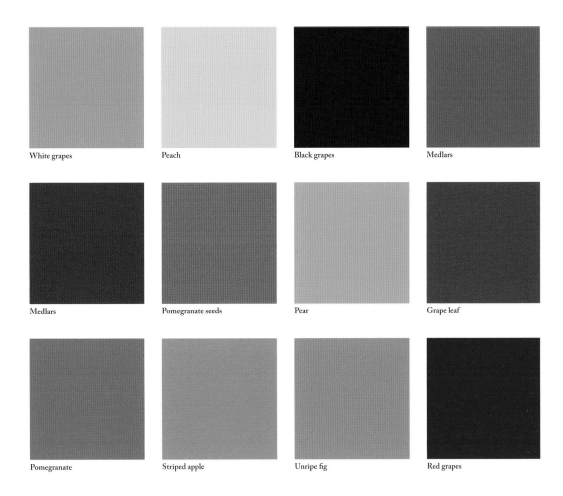

White grapes

Peach

Black grapes

Medlars

Medlars

Pomegranate seeds

Pear

Grape leaf

Pomegranate

Striped apple

Unripe fig

Red grapes

The yellow bills in John James Audubon's
The Birds of America, 1827–38

This subseries of palettes was inspired in large part by the captivating 2018 film *American Animals*—based on the true story of a 2004 library heist (lifting a first edition of Audubon's *Birds of America*, among other rare books) at Transylvania University in Lexington, Kentucky—along with my long-held admiration for Audubon's prints and the astonishing experience of seeing one of his books in person.

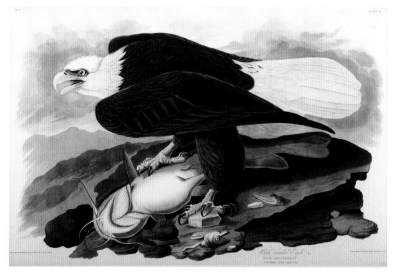

Robert Havell Jr., (British, 1793–1878), after John James Audubon (American, born Haiti, 1785–1851), *White Headed Eagle*, 19th century; hand-colored engraving, etching and aquatint. Courtesy of the Harvard Art Museums/Fogg Museum, bequest of Grenville L. Winthrop.

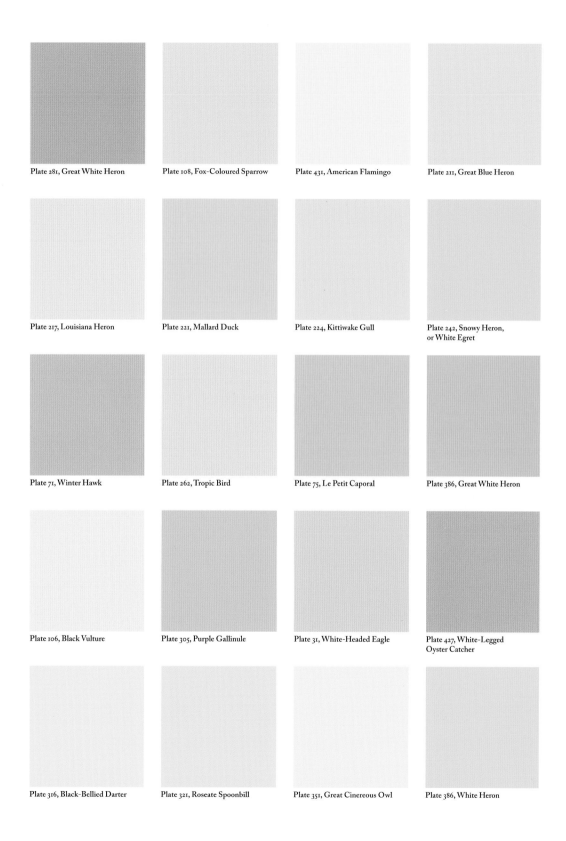

Plate 281, Great White Heron

Plate 108, Fox-Coloured Sparrow

Plate 431, American Flamingo

Plate 211, Great Blue Heron

Plate 217, Louisiana Heron

Plate 221, Mallard Duck

Plate 224, Kittiwake Gull

Plate 242, Snowy Heron,
or White Egret

Plate 71, Winter Hawk

Plate 262, Tropic Bird

Plate 75, Le Petit Caporal

Plate 386, Great White Heron

Plate 106, Black Vulture

Plate 305, Purple Gallinule

Plate 31, White-Headed Eagle

Plate 427, White-Legged
Oyster Catcher

Plate 316, Black-Bellied Darter

Plate 321, Roseate Spoonbill

Plate 351, Great Cinereous Owl

Plate 386, White Heron

The blue bills in John James Audubon's
The Birds of America, 1827–38

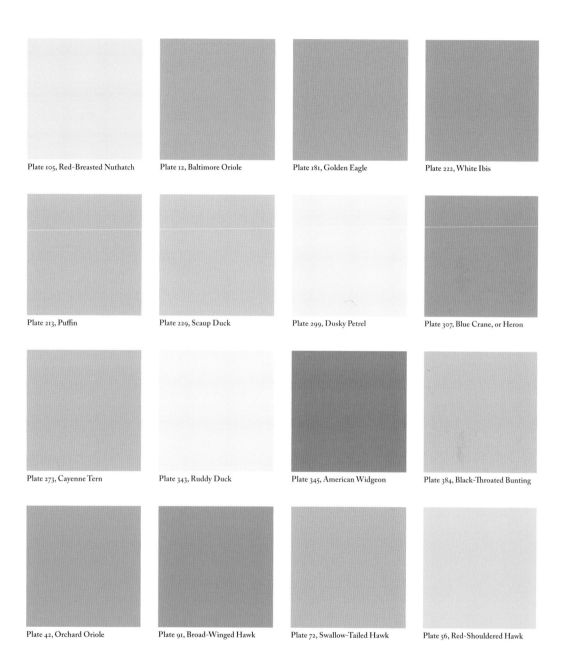

Plate 105, Red-Breasted Nuthatch

Plate 12, Baltimore Oriole

Plate 181, Golden Eagle

Plate 222, White Ibis

Plate 213, Puffin

Plate 229, Scaup Duck

Plate 299, Dusky Petrel

Plate 307, Blue Crane, or Heron

Plate 273, Cayenne Tern

Plate 343, Ruddy Duck

Plate 345, American Widgeon

Plate 384, Black-Throated Bunting

Plate 42, Orchard Oriole

Plate 91, Broad-Winged Hawk

Plate 72, Swallow-Tailed Hawk

Plate 56, Red-Shouldered Hawk

The roseate bills in John James Audubon's
The Birds of America, 1827–38

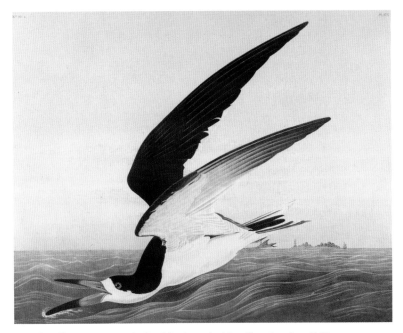

Julius Bien (German, 1826–1909), after John James Audubon (American, born Haiti, 1785–1851). *Black Skimmer, or Shearwater*, 1861; chromolithograph. Courtesy of the Yale University Art Gallery, gift of Dr. Charles F. Brush, III.

Plate 162, Zenaida Dove

Plate 167, Key West Dove

Plate 206, Summer or Wood Duck

Plate 222, White Ibis

Plate 249, Tufted Auk

Plate 251, Brown Pelican

Plate 250, Arctic Tern

Plate 256, Purple Heron

Plate 273, Cayenne Tern

Plate 276, King Duck

Plate 427, Slender-Billed Oyster Catcher

Plate 309, Great Tern

Plate 314, Black-Headed Gull

Plate 323, Black Skimmer, or Shearwater

Plate 331, Goosander

Plate 381, Snow Goose

Plate 397, Scarlet Ibis

Plate 401, Red-Breasted Merganser

Plate 431, American Flamingo

Plate 240, Roseate Tern

The blush of Marie Antoinette's cheeks

This palette, a sea of pale pinks drawing from the blush of Marie Antoinette's cheeks in her many portraits, came about by way of a commission from my friend, the fashion designer Rachel Antonoff, for her fall 2018 collection, Royal B*tch.

Archduchess Marie Antoinette of Austria, 1762

Queen Marie-Antoinette in Hunting Attire, 1771

Portrait of Queen Marie Antoinette of France, 1775

Marie-Antoinette, Queen of France, 1788

Marie Antoinette in a Court Dress, 1778

Marie-Antoinette in Front of the Temple of Love, 1780

Marie Antoinette with the Rose, 1783

Marie-Antoinette, Queen of France, Riding, 1783

Marie Antoinette in a Chemise Dress, 1783

Marie Antoinette, Queen of France and Navarre, 1787

Marie Antoinette, Queen of France, in Coronation Robes, 1775

Portrait of Marie Antoinette, Bust Length, 1800

Thanksgiving in America, 1825–2009

In November 2018, I designed a second palette for Rachel Antonoff, which draws from every Thanksgiving-themed painting I could find in the American canon. The palette features the shade of the pickles in Norman Rockwell's *Freedom From Want* (1943), the wattle of Audubon's *Wild Turkey* (1825), and a turkey pie rendered by Roy Lichtenstein (1964).

Wattle, Wild Turkey, John James
Audubon, 1825

Pie Halo, Boy Watching
Grandmother Trim Pie, J.C.
Leyendecker, 1908

Reg's Socks, Cousin Reginald
Catches the Thanksgiving Turkey,
Norman Rockwell, 1917

Baby Bonnet, Thanksgiving at
Plymouth, Jennie Augusta
Brownscombe, 1925

Pink Floral Dress, Thanksgiving,
Doris Lee, 1935

Celery, Freedom from Want,
Norman Rockwell, 1943

Pickles, Freedom from Want,
Norman Rockwell, 1943

Turkey, Catching the Thanksgiving
Turkey, Grandma Moses, 1944

Turkey Pie, Turkey Shopping Bag,
Roy Lichtenstein, 1964

Rose in Flower Arrangement,
Thanksgiving, John Currin, 2003

Decorative Gourd, Harvest
Display, Wayne Thiebaud, 2008

Pumpkin Filling, Pumpkin Cloud,
Wayne Thiebaud, 2009

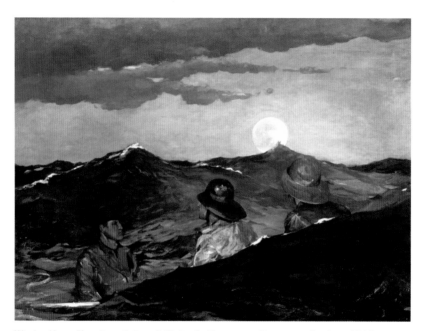

Winslow Homer (American, 1836–1910), *Kissing the Moon*, 1904; oil on canvas. Courtesy of Addison Gallery of American Art, Phillips Academy, Andover, MA, bequest of Candace C. Stimson / Bridgeman Images.

Seascapes, arranged along one horizon line

I arranged seascapes from the twentieth century—with an exception made for Winslow Homer's 1886 *Eight Bells*—along the axis where the sky meets the ocean in each work. (*overleaf* →)

Splash, John Wesley, 1979

Cape Split, Maine, John Marin, 1945

Kissing the Moon, Winslow Homer, 1904

Approach of Rain, George Bellows, 1913

Wave, Night, Georgia O'Keeffe, 1928

Pink Island, White Waves, Milton Avery, 1959

Sea Grasses and Blue Sea, Milton Avery, 1958

Penobscot, Alex Katz, 1999

Rough Seas near Lobster Point,
Robert Henri, 1903

Grey Sea, John Marin, 1938

Eight Bells, Winslow Homer, 1886

Untitled, Alex Katz, 1960

The mountaintops of the diorama paintings in the American Museum of Natural History

The American Museum of Natural History is one of the most magical institutions in New York, though their landscape paintings—dioramas placing the animals in their proper habitats—are often overlooked as works of art. The palette drawn from these dioramas reminds me a bit of Jacob Lawrence's *Migration Series* (1940–41). Lawrence painted the sixty panels simultaneously with a limited range of colors, so when looking at them you can see that he used the same red paint throughout the series. There's a similar through line here in the tones of the skies, whether they're in the North American Hall or the African Hall.

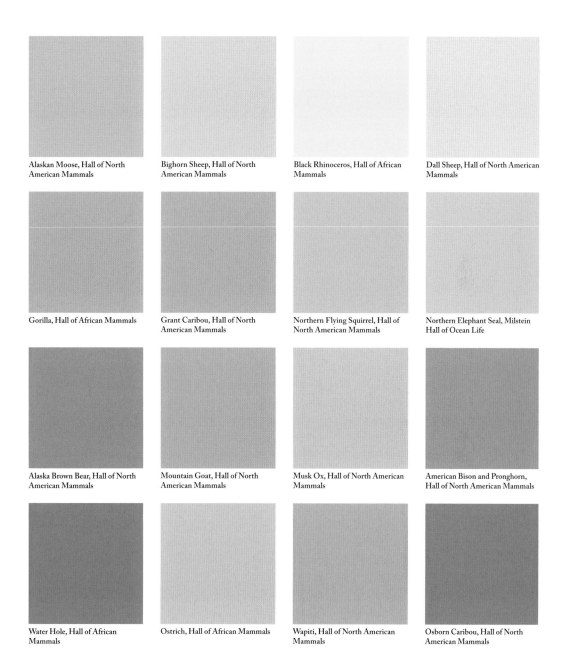

Alaskan Moose, Hall of North American Mammals

Bighorn Sheep, Hall of North American Mammals

Black Rhinoceros, Hall of African Mammals

Dall Sheep, Hall of North American Mammals

Gorilla, Hall of African Mammals

Grant Caribou, Hall of North American Mammals

Northern Flying Squirrel, Hall of North American Mammals

Northern Elephant Seal, Milstein Hall of Ocean Life

Alaska Brown Bear, Hall of North American Mammals

Mountain Goat, Hall of North American Mammals

Musk Ox, Hall of North American Mammals

American Bison and Pronghorn, Hall of North American Mammals

Water Hole, Hall of African Mammals

Ostrich, Hall of African Mammals

Wapiti, Hall of North American Mammals

Osborn Caribou, Hall of North American Mammals

Helen Frankenthaler's orange color fields

This palette is ordered chronologically from the period of Frankenthaler's career when she worked with oil paint thinned by turpentine to her transition to acrylic. It also spotlights the artist's evocative titles. On one of the mornings when I was in the midst of working on this palette, I woke up at 4:30 a.m. with a mosquito buzzing incessantly in my ear and around my head. It was mid-July and one of the longest days of the year. I looked out my window and caught a glimpse of the sunrise, which was a remarkable, potent field of deep orange—just like a Frankenthaler painting.

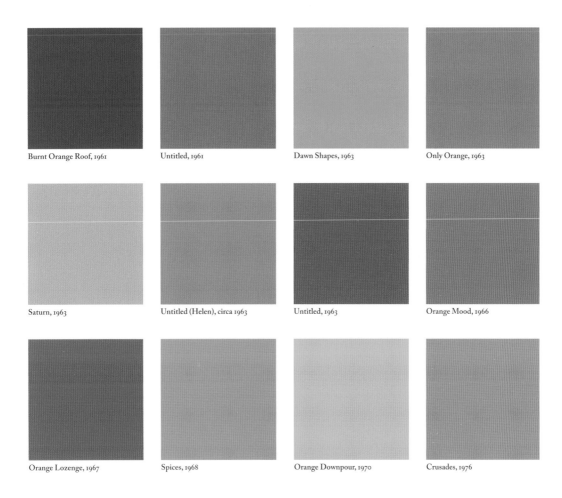

Burnt Orange Roof, 1961

Untitled, 1961

Dawn Shapes, 1963

Only Orange, 1963

Saturn, 1963

Untitled (Helen), circa 1963

Untitled, 1963

Orange Mood, 1966

Orange Lozenge, 1967

Spices, 1968

Orange Downpour, 1970

Crusades, 1976

Charles Burchfield's violets and violas

Burchfield is one of my favorite artists. Violets and violas are just the tip of the iceberg when it comes to botanical variety in his paintings.

Charles Burchfield (American, 1893–1967), *The Woodpecker*, 1955–63; watercolor, gouache, crayon, on pieced paper. Courtesy of Reynolda House Museum of American Art, affiliated with Wake Forest University, gift of Barbara B. Millhouse.

The Violet, 1959

The Woodpecker, 1955–63

White Violets and Abandoned
Coal Mine, 1918

Violets, 1917

White Violets under Pine Bough,
1952

The stripes in Alice Neel's portraits

You're not supposed to wear stripes to a sitting with a photographer (fine stripes can create a moiré effect), but if Neel's portraits are any indication, this rule doesn't hold true for painters. Stripes make a cameo in many of Neel's paintings, a through line among the subjects of varying backgrounds who sat for her. The chair in Neel's studio also has a striped personality of its own.

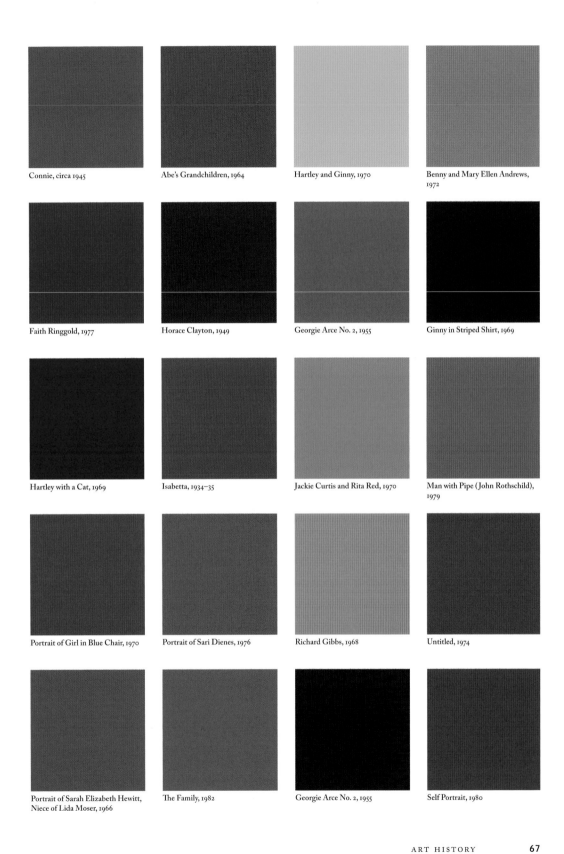

Connie, circa 1945

Abe's Grandchildren, 1964

Hartley and Ginny, 1970

Benny and Mary Ellen Andrews, 1972

Faith Ringgold, 1977

Horace Clayton, 1949

Georgie Arce No. 2, 1955

Ginny in Striped Shirt, 1969

Hartley with a Cat, 1969

Isabetta, 1934–35

Jackie Curtis and Rita Red, 1970

Man with Pipe (John Rothschild), 1979

Portrait of Girl in Blue Chair, 1970

Portrait of Sari Dienes, 1976

Richard Gibbs, 1968

Untitled, 1974

Portrait of Sarah Elizabeth Hewitt, Niece of Lida Moser, 1966

The Family, 1982

Georgie Arce No. 2, 1955

Self Portrait, 1980

The flesh tones of Lucian Freud's ex-wives

This palette evolved out of a fixation with *Girl in Bed* (1952), Freud's
painting of a young, wide-eyed Lady Caroline Blackwood propping herself
up in the Hôtel La Louisiane after the painter and his new wife had eloped
to Paris. The portrait has a notorious history. In 1972, Blackwood married
the poet Robert Lowell (the third marriage for both, Lowell left his second
wife, the writer Elizabeth Hardwick, for Blackwood). By September 1977,
Blackwood and Lowell's relationship was strained, and Lowell left Ireland
and flew to New York. When he arrived in a taxicab outside of the West 67th
Street apartment building where Hardwick lived, Lowell was dead, having
suffered a heart attack. When the building's doorman alerted Hardwick, she
identified Lowell slumped over in the back of the cab, and found *Girl in Bed*,
depicting Lady Caroline Blackwood, under his arm.[1]

Freud painted both of his wives, Kitty Garman and later Lady Caroline
Blackwood, a number of times. The early angular and rigid portraits preceded
the period when the artist rendered human flesh with a dimensionality for
which he is perhaps best known, though each sensibility is unforgiving in its
own way.

NOTE

1 Michael Kimmelman, "Lady Caroline Blackwood, Wry Novelist, Is Dead at 64,"
 New York Times, February 15, 1996, https://www.nytimes.com/1996/02/15
 /nyregion/lady-caroline-blackwood-wry-novelist-is-dead-at-64.html.

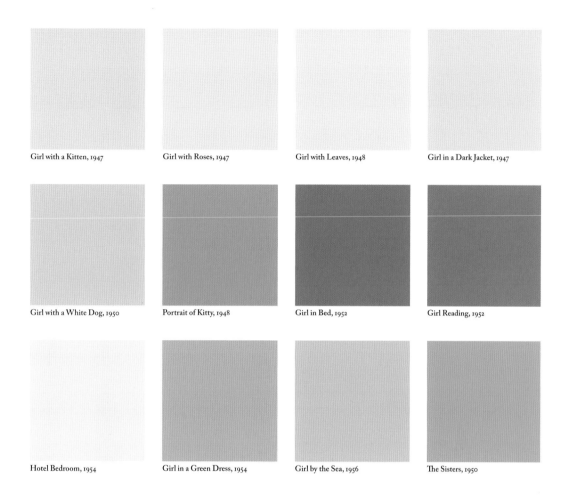

Girl with a Kitten, 1947

Girl with Roses, 1947

Girl with Leaves, 1948

Girl in a Dark Jacket, 1947

Girl with a White Dog, 1950

Portrait of Kitty, 1948

Girl in Bed, 1952

Girl Reading, 1952

Hotel Bedroom, 1954

Girl in a Green Dress, 1954

Girl by the Sea, 1956

The Sisters, 1950

Fairfield Porter's skies

Porter spent much of his time painting his surroundings in Southampton, New York, and on Great Spruce Head Island, Maine.

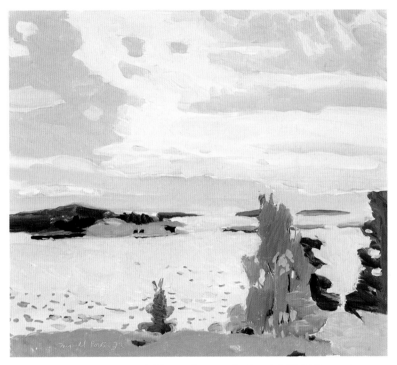

Fairfield Porter (American, 1907–1975), *Morning Sky*, 1972; oil on board. © Eric W. Baumgartner.

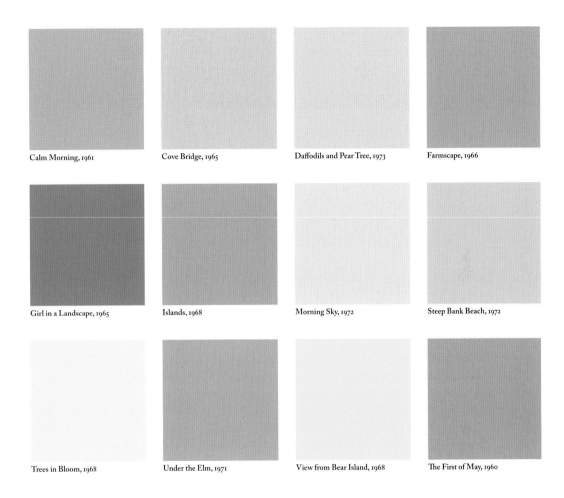

Calm Morning, 1961

Cove Bridge, 1965

Daffodils and Pear Tree, 1973

Farmscape, 1966

Girl in a Landscape, 1965

Islands, 1968

Morning Sky, 1972

Steep Bank Beach, 1972

Trees in Bloom, 1968

Under the Elm, 1971

View from Bear Island, 1968

The First of May, 1960

CONTEMPORARY ART

The Typologists

first wrapped my head around the idea of a typology in a class called Image Bank, taught by artist and RISD professor Lisa Young in 2014. In its broadest terms, creating a typology refers to the practice of classifying objects or images by general type. The class revolved around collecting and creating archives as an engine that revs an artistic process, not necessarily to cull for inspiration but rather to mold us into intentional collectors, such that our collections might become conceptual works of art in and of themselves.

One project from Young's own practice always sticks in my mind as the example that best illustrates the concept of a typology and its left-field possibilities. She began collecting sheep figurines on eBay and amassed, after a long stretch, more than five hundred figurines. She then created an installation entitled *Flocking* (2009), arranging all of the sheep on a tabletop as a single forward-facing flock. In this role, Young plays a shepherd with a bird's eye view. Adapting to each exhibition space, Young's sheep flock in varying formations and populations. When seen grouped together, the differences and variations among the sheep figurines are borderline startling. They vary in posture, size, material, purported breed, and color (of the wool but also of their feet and inside of their ears). The plaster on some figurines is chipping. Some are so saddled with "wool," it seems that they've never been sheared, while others maintain a svelte physique. The artist's practice of collecting sheep figurines never concludes, and so her flock continues to grow.

Young's class also introduced me to the work of Neil Goldberg and his projects like *Missing the Train* (2002–6). During these years, Goldberg lingered on New York subway platforms, videotaping people at the moment when they missed their train. He then created a series of five inkjet portraits by cropping stills from the videotapes centered on the subjects' faces. The low resolution of the still and the uneven quality of the fluorescent light underground created a chiaroscuro effect, bringing to mind the agonized expressions from old master paintings. In subtle yet nuanced ways, the disappointment of missing the train by a hair manifests on the subjects' often sweat-prickled faces. To further differentiate the reactions, the subtitle of each image refers to the subway station where misfortune struck the unwitting subjects that day: *Downtown N/R at 59th Street, Uptown F at West 4th Street*, and so on.

In 2005, Goldberg photographed the elbows of truck drivers propped up and sticking out the window, when he set out on his bicycle and chanced

upon the drivers while paused at red lights. He assembled these photographs as a series of eight prints entitled *Truck Drivers' Elbows*, viewing them as "portraits, with each elbow possessing its own idiosyncrasies and personality."[1]

This method of typology practiced by artists like Goldberg clicked for me. Now I can identify typology as the invisible framework hiding in plain sight in much of the modern and contemporary art that intrigues me. I delight in the game of uncovering typologies in works hung on museum and gallery walls: observing supposedly like objects, finding where their hairs split, sniffing out nuances. I also revel in the challenge of seeking out typologies to call my own.

Lisa Young again masterfully employs typology in her video piece *Lyra Angelica* (2004), a four-paneled split screen of Michelle Kwan performing her skating program to the song "Lyra Angelica" on four separate occasions. While the four performances begin in sync, discrepancies unfurl as Kwan cycles through her routine at varying rates, with slight choreographic tweaks. Watching these moments of contrast unfold alongside each other creates a visual sensation like listening to a song that weaves in and out of tune. The grid can be the tell of a typology, the visual cue after which a typology may creep up.

The grid operates at the center of artist Tschabalala Self's typological approach. In her *Clean House* series (2018), Self becomes the archaeologist of a bodega aisle, rendering its wares—Tide, Clorox, Fabuloso, and Suavitel—as its own portrait with colored pencil, gouache, acrylic, and silkscreen on paper. By installing the series in a grid of nine, Self reveals the minute ways in which each cleaning product differs formally from its neighbors on the shelf, while also flexing the way the medium of silk-screening suits the content, as Self replicates the same plastic jug of fabric softener in the various scents and corresponding colors Suavitel offers.

As part of artist Sara Cwynar's early work, she collected more than fifty Avon cologne bottles in the shape of presidential busts from the seventies for what would become a body of work entitled *Presidential Index* (2015). After aggregating a quorum, she removed the heads of the presidential busts and photographed what remained: shoulders wearing shirts, jackets, and ties. Cwynar photographed eight individual portraits of the cologne bottles against the same black background and printed each to the life-size scale of the artist's own torso. Another set of prints categorizes the busts by most popular cologne scent: in one print, there are two busts of Theodore Roosevelt; in another, there are nineteen George Washingtons. The bottles are organized against a black backdrop but set on risers, so that it mimics a class picture or a Congressional testimony. The resulting prints reek of regality and pretense.

In the 2011 essay "Depth of Field," Janet Malcolm profiles photographer Thomas Struth, perhaps best known for his large-scale photographs of museumgoers in situ. Malcolm places Struth within the context of his teachers, Bernd and Hilla Becher, and presents the legendary Bechers as "cult figures,

known in the photography world for their 'typologies' of water towers, gas tanks, workers' houses, winding towers, and blast furnaces, among other forms of the industrial vernacular…taking the same frontal portrait of each example of the type of structure under study, and arranging the portraits in grids of nine or twelve or fifteen, to bring out the individual variations."[2] The Bechers persisted with this formula for fifty years, photographing their architectural subjects "at the same aboveground-level height and under overcast skies (to eliminate shadows), as if they were specimens for a scientific monograph."[3]

Struth considers this formula the Bechers' attempt to catalog their surroundings as a sort of objective documentation of postwar Germany, when everyone around them was doing their best to avoid looking it straight in the eye. Now, the Bechers represent the old guard of typology, and many of the artists integrating this tool into their practice today are riffing off of the approach the Bechers established and disseminated to their students long ago.

Where else have I happened upon typologies? One summer, working within the Whitney Museum's Education department, I was tasked with organizing the office's internal library, and I took a few liberties to leaf through the strewn books, slowing down the whole enterprise considerably. It was during the shelving process that I came across Roni Horn's series of one hundred photographs entitled *You Are the Weather* (1994–95). The work features closely cropped headshots of the same woman, who traveled around Iceland with the artist during the summer of 1994. The subject is submerged in an Icelandic hot spring in every shot. In this series of photos, we watch her expression to gauge the temperature of the water. We view her as a thermometer, wincing or managing a stoic expression as an indication of the surrounding spring. The series prods: Can a viewer detect the changes in the weather from the subject's expression alone, within a data set of relatively similar images?

One summer afternoon in 2019, I visited the East Village's xxxi community space in New York to see the solo exhibition of the Australian designer Wade Jeffree called *Typographies Greatest Sporting Moments*. On the walls, tiny binder clips held up laser-printed paper in primary colors. While the whole installation created a wallpapered effect, it was, in fact, a series of diptychs assembled like a patchwork. In each diptych, one panel showcases an iconic image of an athlete, either in motion or posing for a portrait, and its corresponding panel isolates the number from the athlete's jersey. The work celebrates a collection of numbers and typefaces that have brushed up against athletic excellence through the transitive property: Magic Johnson's involvement in USA's Dream Team for the 1992 Barcelona Olympics recontextualizes the number 15, while the number 3 forms to the shape of Babe Ruth's back as he leans over home plate with his baseball bat, with Jeffree wavily translating it to the page from Ruth's at-bat hunch.

An artist's fixation on a seemingly arbitrary subject matter is sometimes the most infectious quality of a typology. Take, for example, London-based painter Cathy Lomax, and her 2018 series *Marie Antoinette*, consisting of nine

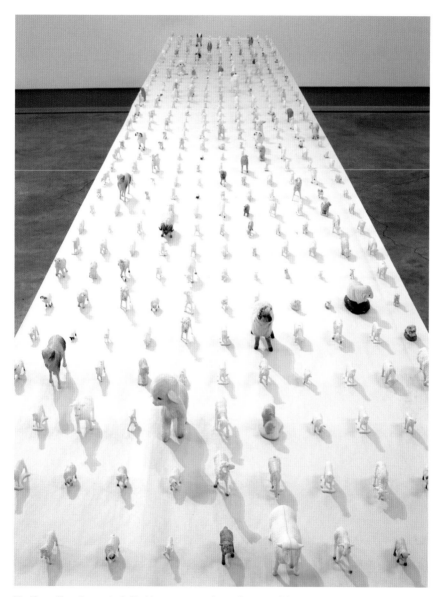

Lisa Young (American, 1964–), *Flocking*, 2009, 500+ sheep. Courtesy of the artist.

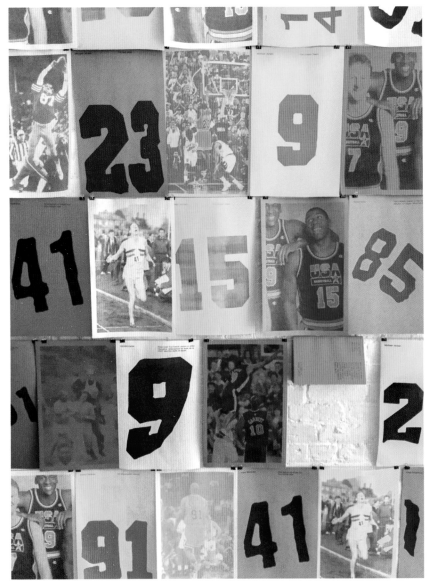

Wade Jeffree (Australian, 1987–), *Typographies Greatest Sporting Moments*, 2016; exhibition view at XXXI. Photo courtesy of the author.

miniature paintings based solely on the actresses Kirsten Dunst and Norma Shearer as they embody Marie Antoinette in their respective films.

In Jenny Odell's series *Satellite Collections* (2009–11), she trawls Google Earth for certain visual criteria: circular farms, shipping containers, waterslide configurations, swimming pools. Odell then isolates the images, adding them to a collage with other like objects from around the world, collapsing geographic distances. This process results in aerial compositions like *77 Waste and Salt Ponds*, *137 Landmarks*, *100 Shipping Containers*, and *Every Outdoor Basketball Court in Manhattan*. In her 2012 project *Signs of Life*, Odell hovers closer to Earth and amasses *202 Billboard Structures*, *153 Signs for Shopping Centers and Entertainment Complexes*, and *295 Roadside Signs*.

Artist Penelope Umbrico similarly mines the internet for her material. Her best-known work is *Suns from Sunsets from Flickr* (2006–ongoing), an evolving installation sparked by the sunset's ubiquity as Flickr's most tagged term in 2006. For this series, Umbrico sources images of sunsets from Flickr and then crops into the glaring sun at the center of each sunset, arranging 4 × 6–inch color prints of those tight crops in a grid format. One installation could comprise anywhere between 541,795 and 30,240,577 setting suns.

Umbrico has since expanded her horizons by identifying other tropes latent on the internet—for example, two bodies of work have evolved out of the exhaustive inventory of ceramic cats she's found on eBay. In one series, entitled *Ceramic Cats (Portraits / eBay)* (2015–ongoing), she creates headshot-like compositions by cropping photos of the feline figurines. In another, *Backwards Facing Ceramic Cats for Sale on eBay* (2015), Umbrico gathered a series of at least sixty backward-facing cats. Ostensibly, the cats are positioned this way to allow the buyer to appraise the ceramic figurine before bidding on it, but with strength in numbers and the recurring phenomenon from various sellers, Umbrico identifies an odd visual motif among the image glut online. She pinpoints other similarly strange motifs on Craigslist, like the unintentional environmental self-portraits of sellers, visible in the reflection of a used television they're putting up for sale.

Not all artists' preoccupations sound terribly appealing or photogenic—some are enough to keep a dry cleaner up at night. Ed Ruscha's 1969 collection, *Stains*, speaks to the artist's fascination with incorporating some semblance of a scientific method into his work. Each sheet of 100 percent rag-content paper has been speckled with a substance. The portfolio boasts seventy-six stains in total, culprits such as salad dressing, egg yolk, witch hazel, bacon grease, beer, gasoline, liquid Drano, and the blood of the artist. This portfolio borders on becoming a color palette in the way that it's been organized as a collection of samples that can then be decoded with an accompanying key of text.

The typology and the visual language of the color palette find overlap again in a book published by designer Joe Rudi Pielichaty in 2016 that drew from a collection he'd started eight years prior. As a student grappling with anxious and melancholic feelings, Pielichaty coped by clipping haphazard

swatches of blue skies out of the travel sections of newspapers and then pasted them into his sketchbooks and photo albums, captioning the image with that sky's location and its proximity to the artist. The exercise's purpose was two-fold: it served as a form of escapism for the designer in overcast Nottingham, England, and as a mechanism for optimism, prompting Pielichaty to think of the blue skies ahead.

The tones of blue—some light, some cloudy, some dark—and their rough, scissored shapes differ from each other in Pielichaty's book, but their where-abouts could not be distinguished from each other without the help of his ori-enting text.[4] While they must have inevitably been photographed at different times of day, the far-flung blue skies have a remarkable sameness about them.

Byron Kim, too, has created his own typology with the help of blue skies. Since 2001, he has endeavored to make a single painting each week.[5] Kim adheres to the following formula in his *Sunday Paintings*: on a 14 × 14-inch canvas, he paints the patch of sky above him, adding a brief diaristic entry in pencil or pen and inscribing the time and place he painted the piece in a cor-ner of the canvas. I'd consider this a form of endurance art, as maintaining a weekly routine over the course of seventeen years requires discipline. Some entries reflect on his relationship with his child, while others offer a recap of his Sunday plans before and those to come after he'd finished his painting. In the midst of August 2014 in Gowanus, Brooklyn, he deliberates on canvas: "Can't decide whether to see the Chris Marker film or go to Smorgasburg, a NY dilemma."

I have long been enamored with the work of Joseph Grigely, a Chicago-based artist who first introduced his series *Conversations with the Hearing* in the 1990s. Grigely, who became deaf at the age of ten, communicates with those who do not know American Sign Language via scribbles on available surfaces, like nearby envelopes, Post-its, cocktail napkins, hotel stationery, paper tablecloths, postcards, menus, claim-check stubs, and gallery invita-tions. At some point, Grigely started saving these snippets of conversations and established an archive of his interactions.

Now, Grigely creates arrangements of these notes, conversations that would be otherwise ephemeral if exchanged vocally. These artifacts present one side of a discussion, and there is something enviable in having this paper trail, the concrete proof of the way other people relate to you, less open to interpre-tation than a vanishing remark said aloud. In his installations, Grigely creates compositions of his collected material, sometimes considering how the crys-tallized quotations relate to each other, other times determined by color. *People Are Overhearing Us* (2012) is a lively multicolor collage with plenty of voices and a penny-candy palette, while pieces like *Thirteen Green Conversations* (2004) and *167 White Conversations* (2004) exhibit more tonal restraint. With unfettered access to the artist's contextless interactions with strangers and friends alike, each with their own scrawl of handwriting, comes a voyeuris-tic rush. So far, the magnum opus of Grigely's ongoing series has manifested

as *White Noise* (2000), made of 2,500 traces of conversations on white or off-white scraps of ephemera, all installed on a concave, oval-shaped wall and recalling a giant monochromatic quilt. Despite the cacophony of chatter on the broad sweep of the wall, the installation's palette soothes, and is itself a kind of meditation on the oversimplified concept of "paper white."

When artists adopt typology and taxonomy into their art practices, they sometimes mimic and subvert processes inherent to the operations of a museum. In their book *Rendez-vous with Art* (2014), Philippe de Montebello, a former director of the Metropolitan Museum of Art, and art critic Martin Gayford discuss collecting as "a sophisticated variety of labelling," and by this logic, museums are viewed as "elaborate labeling institutions."[6] In this exchange, Montebello refers to a conversation he'd had with painter Howard Hodgkin about collecting: "Once the 'design' of the collection has formed in the collector's mind, according to Hodgkin, then things have to be bought out of 'necessity as well as passion.' That he believes is the most dangerous, but also the most creative, phase of collecting." This compulsion is evident in many of the aforementioned artists' practices: Cwynar and her presidential busts, Young and her sheep figurines, and Pielichaty and his blue skies. Internalizing the language and presentation of an institution, artists who work like this are nearly creating a ready-made exhibition for a museum, doing the legwork typically reserved for a curator while discarding some of the stuffiness of outmoded systems when it doesn't serve them.

There's usually something else at play in tandem with a typology. Classification by type often invites other rich subject matters into the fold, whether it's investigating the passage of time, the practice of collecting, or turning a spotlight onto instances of organic mark making and naturally occurring color. Typology encourages an impulse to narrow in on one topic, extrapolate everything you can from a hyper-specific sliver of the world, and become an expert of this niche. At its root, to typologize is to celebrate nuance or the practice of intense observation. It recognizes attention as perhaps the most valuable currency for both an artist and their audience, and rewards the dedicated practice of collecting and cataloging over time.

NOTES

1 "Neil Goldberg: Work: Truck Driver's Elbows," Neil Goldberg website, accessed February 12, 2021, https://neilgoldberg.com/work_elbows.htm.

2 Janet Malcolm, *Forty-One False Starts: Essays on Artists and Writers* (New York: Farrar, Straus and Giroux, 2014), 47.

3 Malcolm, *Forty-one False Starts*, 47.

4 "Joe Rudi Pielichaty—Un Sedicesimo 40: Blue Skies," Un Sedicesimo (One Sixteenth), accessed November 20, 2020, https://www.unsedicesimo.it/dettaglio.php?lin=en&id=51.

5 "Byron Kim: *Sunday Paintings 1/7/01 to 2/11/18*," James Cohan, accessed February 12, 2021, https://www.jamescohan.com/exhibitions/byron-kim3.

6 Philippe de Montebello and Martin Gayford, *Rendez-vous with Art* (London: Thames & Hudson, 2014), 195–96.

The artist's palette, from Anguissola to Botero

Sofonisba Anguissola (Italian, 1532–1625), *Self-Portrait at the Easel*, 1556–57;
oil on canvas. Courtesy of Castle Museum in Łańcut.

William Hogarth, 1757–58

Fernando Botero, 1973

Sofonisba Anguissola, 1556–57

Florine Stettheimer, 1915

Fernando Botero, 2011

Fernando Botero, 1963

The blues of David Hockney's pools

An artist of tremendous multidisciplinary talent, Hockney has been painting swimming pools, a known trope in his work, since he first moved from his native England to Los Angeles in 1964.

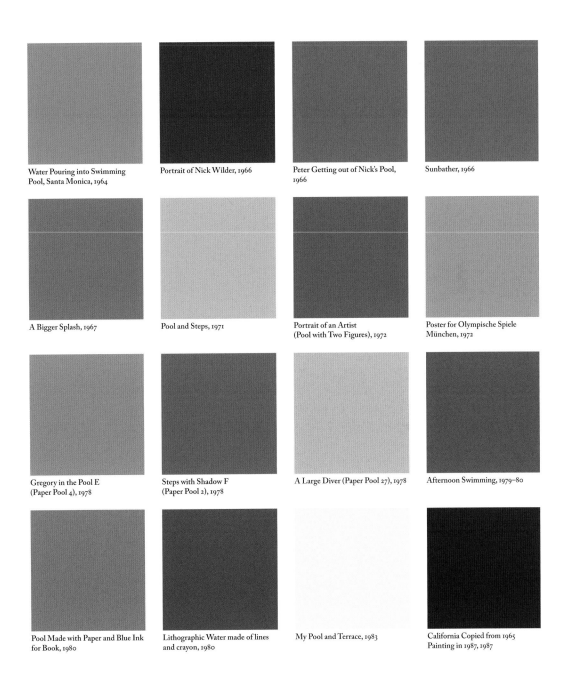

Water Pouring into Swimming
Pool, Santa Monica, 1964

Portrait of Nick Wilder, 1966

Peter Getting out of Nick's Pool,
1966

Sunbather, 1966

A Bigger Splash, 1967

Pool and Steps, 1971

Portrait of an Artist
(Pool with Two Figures), 1972

Poster for Olympische Spiele
München, 1972

Gregory in the Pool E
(Paper Pool 4), 1978

Steps with Shadow F
(Paper Pool 2), 1978

A Large Diver (Paper Pool 27), 1978

Afternoon Swimming, 1979–80

Pool Made with Paper and Blue Ink
for Book, 1980

Lithographic Water made of lines
and crayon, 1980

My Pool and Terrace, 1983

California Copied from 1965
Painting in 1987, 1987

Botero's beverages

One gets the sense that Fernando Botero may have dozens of empty glasses, once filled with guava juice and Orangina, strewn throughout his home and studio. The half-full vessels are present enough in at least twenty of his paintings to warrant a subplot of their own.

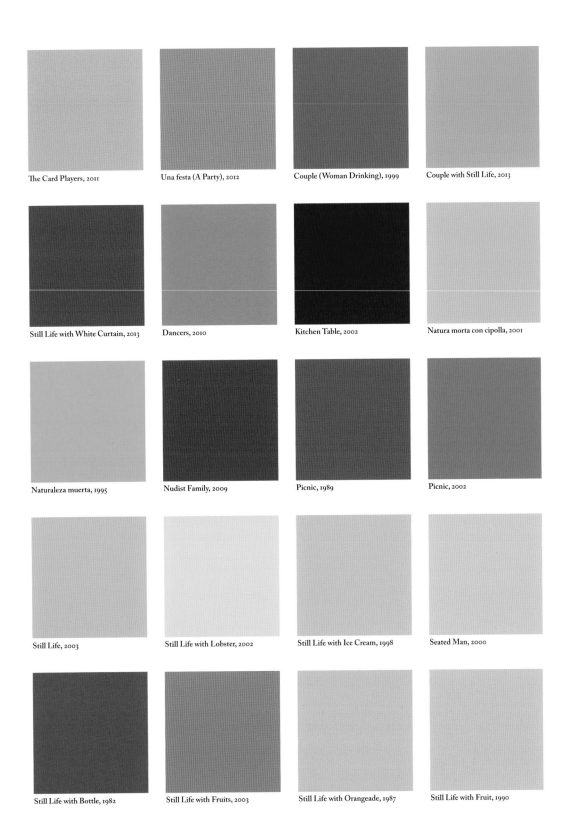

The Card Players, 2011

Una festa (A Party), 2012

Couple (Woman Drinking), 1999

Couple with Still Life, 2013

Still Life with White Curtain, 2013

Dancers, 2010

Kitchen Table, 2002

Natura morta con cipolla, 2001

Naturaleza muerta, 1995

Nudist Family, 2009

Picnic, 1989

Picnic, 2002

Still Life, 2003

Still Life with Lobster, 2002

Still Life with Ice Cream, 1998

Seated Man, 2000

Still Life with Bottle, 1982

Still Life with Fruits, 2003

Still Life with Orangeade, 1987

Still Life with Fruit, 1990

The paint on Kerry James Marshall's smocks

Three of my favorite Kerry James Marshall paintings depict artists at work, or standing statuesque alongside their giant palettes, wearing paint-slathered smocks draped over their plain clothes.

Untitled (Painter), 2008

Untitled (Painter), 2008

Untitled (Painter), 2008

Untitled (Studio), 2014

Untitled (Studio), 2014

Untitled (Studio), 2014

Untitled (Painter), 2008

Untitled (Painter), 2008

Untitled (Painter), 2008

The greens of the garnishes in Wayne Thiebaud's still lifes

Thiebaud's sandwiches and hors d'oeuvres are often topped off with a green garnish, like an olive or a pickle slice.

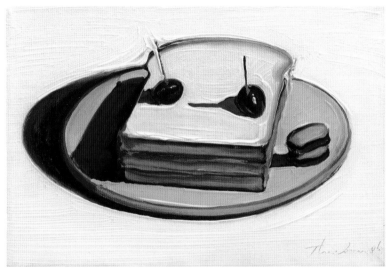

Wayne Thiebaud (American, 1920–), *Sandwich*, 1963; oil on canvas.
Photo © Christie's Images / Bridgeman Images.

Hamburger Counter, 1961

Buffet, 1972–75

Cakes, 1963

Cakes No. 1, 1967

Colorful Cakes, 1990

Delicatessen, 1964/2010

Lemon Meringue Pie Slices, 1990

Hors d'oeuvres, 1963

Sandwich, 1963

Triangle Thins, 1971

Two Hamburgers, 2000

Appetizers (from The Physiology of Taste series), 1994

Double Decker, 1961

Glass of Wine & Olives, 2002

Chez Panisse Desserts Study, 1984

Cracker Rows, 1963

Etel Adnan's suns

The sun—often seen over Marin County's Mount Tamalpais—figures prominently in the work of the Lebanese painter Etel Adnan, who called California home for more than fifty years. She paints with a palette knife on compact canvases about the size of a book.

Equilibre, 2018

Le poids du monde II, 2016

Poids du monde V, 2018

Power of the Sun, 2017

Untitled, 2014

Untitled, 2014

Untitled, 2015

Untitled, 2014

John Currin's blondes

Park City Grill, 2000

"Federal" Rachel, 2006

Blond Angel, 2001

Big Hands, 2010

Constance Towers, 2009

Flora, 2010

Pushkin Girl, 2007

Happy House Painters, 2016

Tapestry, 2013

Lynette & Janette, 2013

Rachel in Fur, 2002

Nice 'n Easy, 1999

Nude in a Convex Mirror, 2015

The Dogwood Thieves, 2010

Lake Place, 2012

Rippowam, 2006

Stamford after Brunch, 2000

Thanksgiving, 2003

The Scream, 2010

Girl in Bed, 1993

The letter "E" in Mel Bochner's paintings

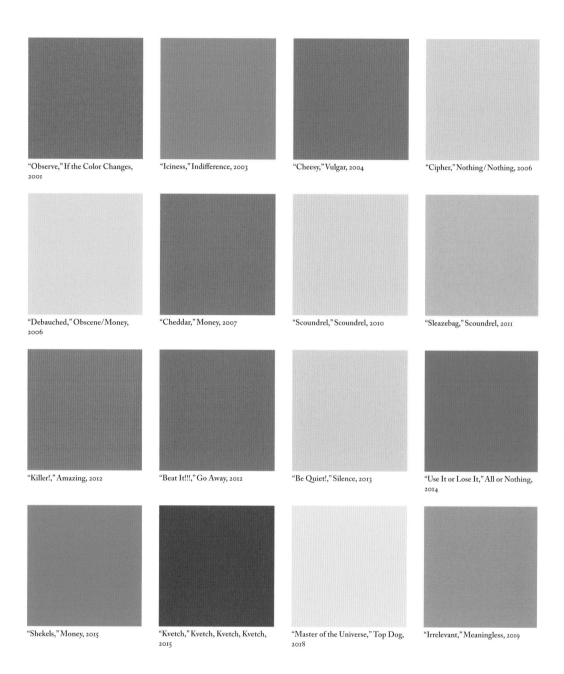

"Observe," If the Color Changes, 2001

"Iciness," Indifference, 2003

"Cheesy," Vulgar, 2004

"Cipher," Nothing/Nothing, 2006

"Debauched," Obscene/Money, 2006

"Cheddar," Money, 2007

"Scoundrel," Scoundrel, 2010

"Sleazebag," Scoundrel, 2011

"Killer!," Amazing, 2012

"Beat It!!!," Go Away, 2012

"Be Quiet!," Silence, 2013

"Use It or Lose It," All or Nothing, 2014

"Shekels," Money, 2015

"Kvetch," Kvetch, Kvetch, Kvetch, 2015

"Master of the Universe," Top Dog, 2018

"Irrelevant," Meaningless, 2019

POP CULTURE

The Color Strategy

I've been curious about the cleverness of brands that implement a certain strategy with color: maintaining a suite of core products, where the most popular, long-standing items will always be on offer, but in a rotating cast of colorways. Marimekko with its Finnish floral textiles, Le Creuset with its cast-iron pots, and Fjällräven with its rectangular backpacks all infuse their hero products with a chromatic newness.

This color-centric strategy prevents the classic design of a well-known product from growing stale and outdated while keeping loyal customers engaged, ever tempted by the colorway that seems even newer, better, fresher, a touch more thrilling than the last. While touting optionality as a virtue and appealing to a wide net of customers, this colorway strategy also feeds into a mentality best distilled by the dilemma that arises when getting an ice cream cone with a friend. After scrupulously scanning the menu for the flavor that speaks to you, you end up regretting your choice and craving the mint chocolate chip your friend ordered, simply because she has it and you don't.

Iterating on a product's available color palette creates a sense of novelty —a constant pursuit of the twenty-first-century brand. These companies need jolts of newness to cut through the noise of the internet, where customers are delighted by the introduction of something novel, only to grow accustomed to it all too quickly. This scheme capitalizes on the customer's impulsive desire to have the newest version of something. Swapping out old colors for new ones is one of the easiest ways to catch a customer's eye. Here, certain brands approach the color wheel a bit like a lazy Susan: by spinning the disc and doling out new color palette options over time, they can pique the consumer's interest again and again with a lively update to a reliable mainstay.

Le Creuset, the company known for its enameled cast-iron cookware with smooth, sand-colored interiors, came to be when Armand Desaegher, a Belgian cast-iron specialist, and Octave Aubecq, an enameling expert, joined forces and started a foundry together in Fresnoy-le-Grand, France. In 1934, they introduced their handcrafted cocotte, or Dutch oven, in the debut shade of Volcanique (now Flame), a deep orange inspired by the glow of molten iron in the foundry's cauldron.[1] Julia Child can be credited for Le Creuset's expatriate popularity in the United States; her often televised tomato-red, six-quart cocotte, which she called her "soup pot," today resides in the collection of the National Museum of American History.[2]

In Bee Wilson's 2012 book, *Consider the Fork: A History of How We Cook and Eat*, the historian traces the evolution of Le Creuset's colors, among its cocottes, ramekins, baking dishes, tagines, woks, flan dishes, and grill pans, as the brand has adapted to the tastes of kitchen design over the years: "Flame Orange in the 1930s; Elysees Yellow in the 1950s; Blue in the 1960s (the color was suggested by [food writer] Elizabeth David, inspired by a pack of Gauloises cigarettes)"; and Teal, Cerise, and Granite around 2012.[3]

At the time of writing, you could buy a Le Creuset round Dutch oven in nineteen different colors, including the original Flame, as well as Cerise (a cherry red), Berry (a deep pink), Nectar (yellow), Fig (exactly what it sounds like—elements of both the Mission fig and the Brown Turkey fig at play here), a tinged white Meringue, a charred color called Oyster, a matte black called Licorice, a *Wizard of Oz*–adjacent color of Emerald Green, and a blue gray called Sea Salt. It's customary for devoted Le Creuset patrons to determine a signature color, sometimes in the arrangement of their wedding registry, and stick to it, though I'd argue that it's more fun to see an avid collector's spoils after amassing a hodgepodge of colors and shapes from years of steady acquiring and vintage sleuthing. These days, the roster of discontinued colors includes Chocolate, Burgundy, and Sugar Pink Matte, a pale shade that rode an en vogue wave around the time of its release in 2017.

Wondering about the lifespan of a color, I dialed up Patrick O'Donnell, color consultant of Farrow & Ball, the luxury paint company based in Dorset, England, which was first hailed as the go-to brand for accurate period colors. The company showcases their color selections in a color-chart format, the gradient beginning with off-whites that transition into neutrals, tans, and beiges, followed by pinks, reds, yellows, greens, blues, and darks. O'Donnell refers to the colors as idiosyncratic, "a little more muted, with a dose of black in most colors, which knocks some of the intensity out."[4] The idiosyncrasies don't stop at the more subtle color scheme. Farrow & Ball has established a reputation for its eclectic color names, the irreverence of which poses a contrast to the historically rooted colors, with examples such as Elephant's Breath, Arsenic, Mouse's Back, and Cabbage White.

The company acknowledges its customer base's dueling appetites for both novelty and consistency by maintaining a color card restrained both in its tones and its optionality. In order to maintain a tight roster of colors, Farrow & Ball retires shades to an archive collection. "Every time we introduce new colors, we take nine out of the color chart and add nine new colors," O'Donnell explains. It's a relatively limited selection compared to competitors like Benjamin Moore, with its encyclopedic inventories. As O'Donnell says, "132 colors in our current color collection is hardly fettered."[5]

What does the color archive system look like in practice? "In the eighties and nineties, there was much more of a vogue for yellows," O'Donnell says. "As a sort of trend, yellows have diminished somewhat over the last twenty years, so our yellow group has diminished massively, and it's much smaller on the

Maija Isola (Finnish, 1921–2001), *Unikko*, 1964. Courtesy of Marimekko.

current color card than it would have been in the nineties." Keeping the palette from becoming too noisy necessitates a fair amount of movement: "Every two or three years, the archive gets ever so slightly bigger. It almost felt sort of churlish that we weren't capitalizing on some of the really beautiful colors in there, so we've now put our archive of colors on our website for the first time ever." (An archived favorite of O'Donnell's is an off-white called Clunch.)

When I ask if there's a typical lifespan for a color, O'Donnell says no such formula exists. "Sometimes we'll introduce the color, and then it won't work at all, and it disappears quite quickly. We introduced a strong, almost-chromium yellow about five or six years ago. And I think that lasted one life cycle until the next colors came out." Despite the lack of fanfare and its fleeting moment on the color card, Farrow & Ball still ushered this unpopular yellow to the archive collection rather than striking it from the record: "Everything moves to the archive. The only things that don't necessarily sit in the archive are our bespoke colors that we create for people or institutions."[6]

Do colors, or colorways, have a lifespan over at Marimekko? I'm not alone in considering the Unikko print (Finnish for "poppy," the flower) as the ultimate powerhouse of Marimekko's brand recognition. A survey of my closet would also expose me to be under its spell. I'm guilty on the count of amassing my own Unikko collection over the course of twelve years, buying three cotton dresses in the same cut but varying color palettes in the print (one springy green and orange; one pink, purple, and aqua; and one pink and brown) as well as a T-shirt (orange and blue) and a twin-sized duvet cover (yellow) with matching throw pillows.

When I corresponded with Minna Kemell-Kutvonen, head of print design at Marimekko, in July of 2020, she told me the unlikely origin story of the brand's "true design icon," the Unikko print. As the story goes, Marimekko cofounder Armi Ratia publicly forbade all Marimekko designers from creating floral prints, citing her theory that flowers would always be more beautiful in nature than in a two-dimensional representation. In 1964, designer Maija Isola defied Ratia's restrictions and designed an entire range of floral and environmentally inspired prints, which included what would become known as Unikko. When Isola presented her prints to Ratia, the avant-garde, bold take on the poppy flower was enough to change Ratia's mind. The Unikko print has persisted in Marimekko's collections ever since as a symbol of the beauty that can come from breaking the rules. Isola went on to design more than five hundred prints for the Finnish brand in the sixties and seventies, many of which are among the most iconic and recognizable Marimekko prints today.[7]

When Kemell-Kutvonen and her team start cooking up a new collection, a theme provides guidelines for how they'll update archival prints (which they always do), with new applications, techniques, scales, or colorways. A part of this process involves investigating the original colorways of some of the 3,500 prints in their archive.

"From the original colorways, we work to create interesting, modern tones and color combinations," Kemell-Kutvonen says. Occasionally, rather than conceptualizing a brand new color palette, the designers find that an original colorway aligns with the theme and is metaphorically taken off ice, finding new context and new fans. Marimekko's collections also include entirely new print designs from the younger generation of designers continuing in the brand's tradition: "The ultimate tribute for the timelessness of our print designs is that it is not really possible to say which design dates back to which time," Kemell-Kutvonen tells me. "They are all equally relevant today as when originally created."[8]

In response to my curiosity about how the Unikko colorways might rank in the Marimekko team's internal favor, Kemell-Kutvonen answered that "the original red colorway of 'Unikko' still has a superior energy." I loved the way she characterized this, and wasn't terribly surprised to learn that in recent years, more delicate and unassuming colors have seen a surge in popularity, giving the print newfound sense of belonging in homes with more subdued color schemes. The success of Marimekko's Unikko print is an emblem for the brand's broader design philosophy, which has always been sustainably minded: "We want to create timeless, functional, and durable products that bring people long-lasting joy that they will not want to throw away."

In some cases, a simple, straightforward blueprint can be the conduit for a riskier color direction. Fjällräven's classic Kånken backpack has surged in popularity in recent years, though the product dates back to 1978, when it was designed to help prevent back problems among Swedish schoolchildren, and found its niche in the country's preschools and nature schools. Online, the backpack is available online in thirty-seven colors—Frost Green, Acorn, Guacamole among them—that sound so chipper, you can only imagine how much more poetic their names are in Swedish. Years later, these bright, compact backpacks have become ubiquitous on the backs of commuters in coastal American cities. Google Trends indicates that interest started to bubble in the back-to-school shopping period of 2016, and hit a fever pitch in July 2018.

This methodology isn't just practiced among legacy brands. A contemporary example of a business that seizes on this system is activewear brand Outdoor Voices, founded in 2014. Its keen, color-oriented business model is what attracted me to the athleticwear company when I applied for a job there in 2016. The brand's signature styles, like a sports bra called the Athena crop top and leggings called the Tri-Tone, stitched together large panels of contrasting colored fabric in a custom polyester-spandex blend the brand called "textured compression." The aesthetic effect of these garments is that of wearing an Ellsworth Kelly on a treadmill. When I worked there, the more neutral colors were considered a part of the "core" collection, to be offered year-round, while the seasonal collections centered around limited edition color combinations.

My time at Outdoor Voices gave me a front row seat to witnessing the customer's relationship to color and the value of perceived newness. It was my

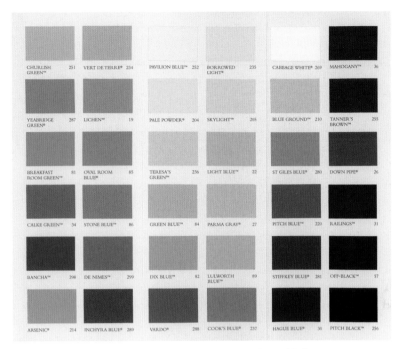

Farrow & Ball Color Brochure, 2020. Scan by author. Courtesy of Farrow & Ball.

first job out of college, working as the assistant to the brand's editorial director, in a narrow office on Canal Street that the team had long outgrown. I got my own taste of what it was like to manage the colors behind the scenes at one point, while the company was in the "we-all-wear-a-lot-of-hats" stage of startupdom. One evening, I went home with a sheet of twenty-two colors— fuzzy reproductions of the soon-launching fabrics, each barely visible as a tiny thumbnail—pressed into my palm. My assignment was to give each color its customer-facing name—the only requirement for my color names was that they each had to be naturally occurring—and I enlisted my dad to help. We squinted at the array of teensy samples of fabric from the production team, and jotted down dozens of ideas (given the expertise of my coconspirator, an overwhelming number of these ideas seemed to be names of either birds or fish). Eventually, my supervisors whittled down our ideas to twenty-two final names, and so swaths of heathered Textured Compression and TechSweat™ found customer-facing identities like Marine, Shiitake, Midnight, Cranberry, Plum, and Orchid in the fall and holiday collections of 2016.

This customer retention tactic—enticing customers to return for a core product reinvented in a fresh colorway—was baked into the company's genome. In a 2020 story for *Inc.* Magazine, posed as a sort of postmortem reflecting on her time as the company's CEO, Outdoor Voices founder Tyler Haney acknowledged her strengths, "I was super clear on the vision. Where

I'm best is the product, the creative, the brand, the connection to the customer. And I'd push us constantly to renew ourselves."[9] While customers and critics often fixate on Outdoor Voices' uncomplicated slogan—"Doing Things"— and the tote bags emblazoned with a custom sans serif typeface, I consider this spirit of renewal, especially as it pertains to color, to be the real workhorse of OV's indelible branding. The unpredictable cycling of colorways and color blocks remains the underrated key ingredient of the brand's secret sauce.

These methodologies are not entirely divorced from the art world. Consider Warhol's often employed practice of producing one screen print, *Marilyn* (1967) for example, and reproducing the portrait in a whole host of colorways. Now there's a *Marilyn* in every flavor you can imagine, floating around museum collections and auction houses.

Robert Indiana's oeuvre is the same way—he designed what became his most well-known work, *LOVE*, in 1964, and it has spawned dozens of variations in both form and colorway in the years following the initial sketch, some of which were authorized by the artist while others were not. While the artist has attributed the color scheme in the original *LOVE* graphic to the red and green of the Phillips 66 gasoline station, where his father worked, against the cerulean blue of the "Hoosier sky," writers have speculated a link to a colorway by artist Ellsworth Kelly, who painted *Red Blue Green* in 1963, and with whom Indiana reportedly had a romantic entanglement.[10] With their commercial and mass appeal, as well as infinite capacity for new colors, the *Marilyn*s and the *LOVE*s forever toe the line between franchise and serial masterpiece.

To build a system that replenishes a well-worn, beloved product with a new colorway, making something once familiar desirable again, marries design with cunning, creating an engine that revs brands like Marimekko, Le Creuset, and Outdoor Voices. Inventing a template that can be the vehicle for so many color combinations, withstanding the test of time—and each generation's new and evolving aesthetic preferences—is a true mark of good design.

NOTES

1 Hillary Davis and Steven Rothfeld, *Le French Oven* (Layton, UT: Gibbs Smith, 2015), 18–24.

2 Rachael Narins, *Cast Iron: The Ultimate Cookbook* (Kennebunkport, ME: Cider Mill Press Book Publisher, 2019), 707; "Cocotte, ca. 1976." National Museum of American History, accessed March 12, 2021, https://americanhistory.si.edu/collections/search/object /nmah_1001137.

3 Bee Wilson, *Consider the Fork: A History of How We Cook and Eat* (New York, NY: Basic Books, 2012), 30–31.

4 Patrick O'Donnell, telephone interview with the author, July 7, 2020.

5 O'Donnell, July 7, 2020.

6 O'Donnell, July 7, 2020.

7 Minna Kemell-Kutvonen, email correspondence with the author, July 16, 2020.

8 Kemell-Kutvonen, July 16, 2020.

9 Tom Foster, "Ty Haney Speaks Out About Outdoor Voices' Missteps—and What Comes Next," *Inc.*, October 28, 2020, https://www.inc.com/magazine/202011/tom-foster /tyler-haney-outdoor-voices-ceo-founder-startup-comeback.html.

10 Barbaralee Diamonstein-Spielvogel, *Inside New York's Art World* (New York: Rizzoli, 1979), 151–66; "Teacher Guide: Robert Indiana: Beyond LOVE," Whitney Museum of American Art, September 26, 2013, https://whitney.org/education/for-teachers/teacher-guides /robert-indiana; Bradford R. Collins, *Pop Art* (London: Phaidon Press, 2012).

Tonya Harding's figure skating costumes per competition

Organized chronologically, this palette pays homage to Harding's homemade costumes in the colors of her choice. My fascination with Harding began when my mother regaled me with her tales of reporting on the 1994 Winter Olympics in Lillehammer for *Sports Illustrated*.

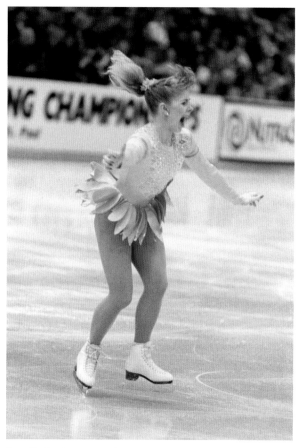

Tonya Harding becomes the first American woman to perform a triple axel in competition on February 16, 1991, in Minneapolis. Courtesy of AP Photo/Jim Mone.

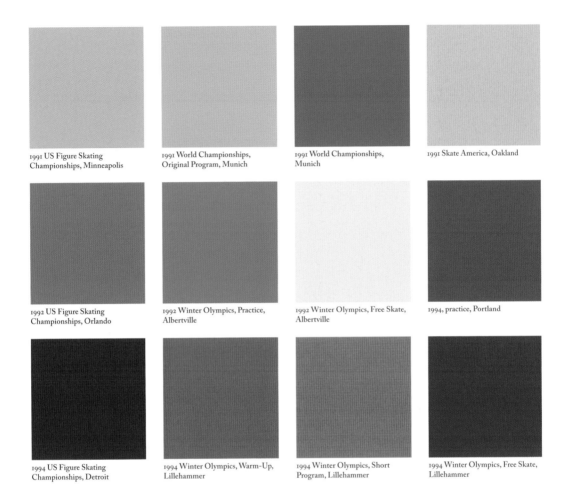

1991 US Figure Skating
Championships, Minneapolis

1991 World Championships,
Original Program, Munich

1991 World Championships,
Munich

1991 Skate America, Oakland

1992 US Figure Skating
Championships, Orlando

1992 Winter Olympics, Practice,
Albertville

1992 Winter Olympics, Free Skate,
Albertville

1994, practice, Portland

1994 US Figure Skating
Championships, Detroit

1994 Winter Olympics, Warm-Up,
Lillehammer

1994 Winter Olympics, Short
Program, Lillehammer

1994 Winter Olympics, Free Skate,
Lillehammer

Prince's concert outfits

Here are glimpses of what Prince wore on stage from 1981 to 2010. The tickets for the Purple Rain tour instructed concertgoers to "wear something purple."

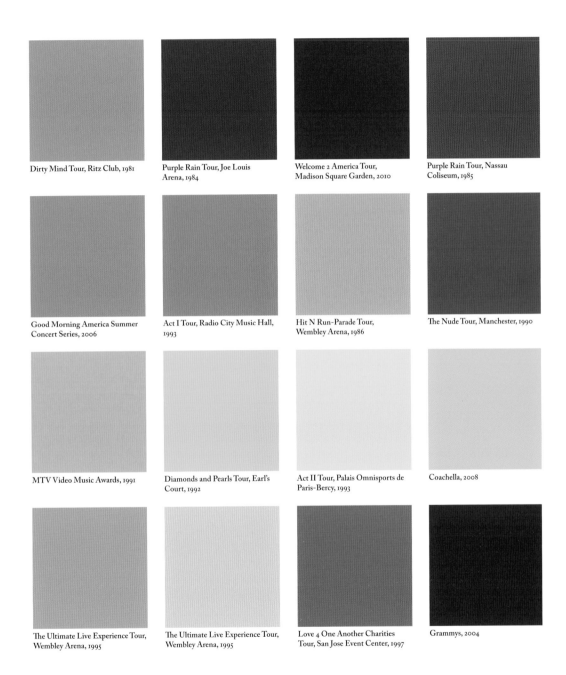

Dirty Mind Tour, Ritz Club, 1981

Purple Rain Tour, Joe Louis Arena, 1984

Welcome 2 America Tour, Madison Square Garden, 2010

Purple Rain Tour, Nassau Coliseum, 1985

Good Morning America Summer Concert Series, 2006

Act I Tour, Radio City Music Hall, 1993

Hit N Run-Parade Tour, Wembley Arena, 1986

The Nude Tour, Manchester, 1990

MTV Video Music Awards, 1991

Diamonds and Pearls Tour, Earl's Court, 1992

Act II Tour, Palais Omnisports de Paris-Bercy, 1993

Coachella, 2008

The Ultimate Live Experience Tour, Wembley Arena, 1995

The Ultimate Live Experience Tour, Wembley Arena, 1995

Love 4 One Another Charities Tour, San Jose Event Center, 1997

Grammys, 2004

Paul Thomas Anderson's oeuvre

Made as a commission for author Emma Straub, this palette amplifies the chromatic eccentricities in Anderson's *Hard Eight* (1996), *Boogie Nights* (1997), *Magnolia* (1999), and *Inherent Vice* (2014).

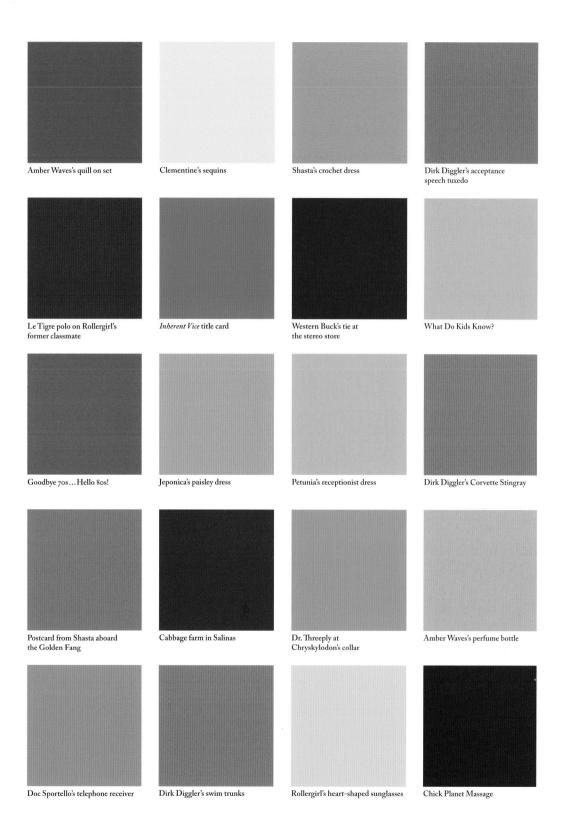

Amber Waves's quill on set

Clementine's sequins

Shasta's crochet dress

Dirk Diggler's acceptance speech tuxedo

Le Tigre polo on Rollergirl's former classmate

Inherent Vice title card

Western Buck's tie at the stereo store

What Do Kids Know?

Goodbye 70s…Hello 80s!

Jeponica's paisley dress

Petunia's receptionist dress

Dirk Diggler's Corvette Stingray

Postcard from Shasta aboard the Golden Fang

Cabbage farm in Salinas

Dr. Threeply at Chryskylodon's collar

Amber Waves's perfume bottle

Doc Sportello's telephone receiver

Dirk Diggler's swim trunks

Rollergirl's heart-shaped sunglasses

Chick Planet Massage

Craig Sager's suits, in chronological order over
the course of his sportscasting career

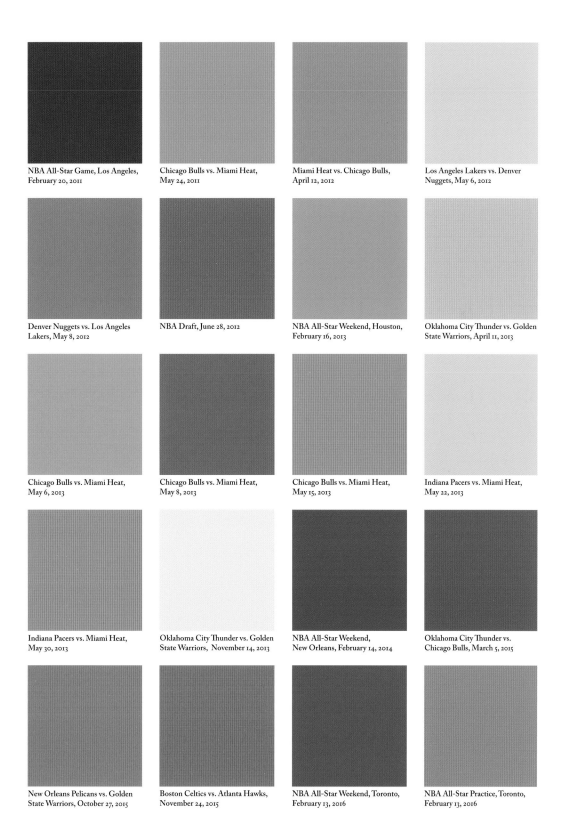

NBA All-Star Game, Los Angeles,
February 20, 2011

Chicago Bulls vs. Miami Heat,
May 24, 2011

Miami Heat vs. Chicago Bulls,
April 12, 2012

Los Angeles Lakers vs. Denver
Nuggets, May 6, 2012

Denver Nuggets vs. Los Angeles
Lakers, May 8, 2012

NBA Draft, June 28, 2012

NBA All-Star Weekend, Houston,
February 16, 2013

Oklahoma City Thunder vs. Golden
State Warriors, April 11, 2013

Chicago Bulls vs. Miami Heat,
May 6, 2013

Chicago Bulls vs. Miami Heat,
May 8, 2013

Chicago Bulls vs. Miami Heat,
May 15, 2013

Indiana Pacers vs. Miami Heat,
May 22, 2013

Indiana Pacers vs. Miami Heat,
May 30, 2013

Oklahoma City Thunder vs. Golden
State Warriors, November 14, 2013

NBA All-Star Weekend,
New Orleans, February 14, 2014

Oklahoma City Thunder vs.
Chicago Bulls, March 5, 2015

New Orleans Pelicans vs. Golden
State Warriors, October 27, 2015

Boston Celtics vs. Atlanta Hawks,
November 24, 2015

NBA All-Star Weekend, Toronto,
February 13, 2016

NBA All-Star Practice, Toronto,
February 13, 2016

Walt Frazier's suits, in chronological order over the course of his sportscasting career

Would you rather wear Frazier's or Sager's wardrobe for the rest of your days?

New York Knicks vs. New Orleans Hornets, March 27, 2009

Sacramento Kings vs. New York Knicks, November 17, 2010

New York Knicks vs. Boston Celtics, April 23, 2013

New York Knicks vs. Milwaukee Bucks, October 30, 2013

Sacramento Kings vs. New York Knicks, March 26, 2014

Miami Heat vs. New York Knicks, November 23, 2015

NBA All-Star Game, New York, February 15, 2015

New York Knicks vs. New Orleans Pelicans, January 19, 2015

Atlanta Hawks vs. New York Knicks, December 28, 2016

Los Angeles Clippers vs. New York Knicks, March 11, 2016

New York Knicks vs. Boston Celtics, January 12, 2016

New York Knicks vs. Memphis Grizzlies, October 29, 2016

NBA Draft Lottery, May 16, 2017

New York Knicks vs. Washington Wizards, December 3, 2018

Brooklyn Nets vs. New York Knicks, December 26, 2019

New York Knicks vs. Detroit Pistons, April 10, 2019

New York Knicks vs. Los Angeles Clippers, March 24, 2019

New York Knicks vs. Los Angeles Lakers, March 17, 2019

Cleveland Cavaliers vs. New York Knicks, February 3, 2020

Houston Rockets vs. New York Knicks, February 24, 2020

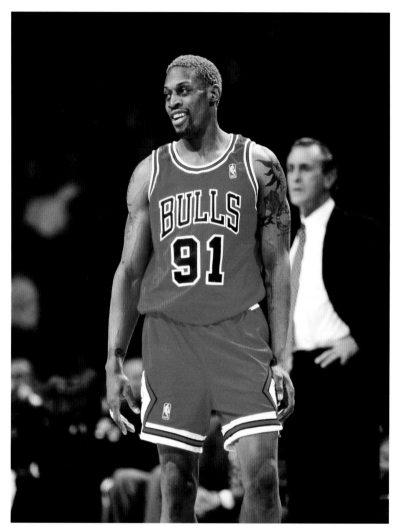

Chicago Bulls' Dennis Rodman plays in an NBA game against the Miami Heat in 1997 in Miami.
Courtesy of Tom DiPace via AP.

Dennis Rodman's hair dye, in chronological order over the course of his NBA career

I consider Dennis Rodman to be one of the great colorists of our time. (*overleaf*→)

San Antonio Spurs vs. Washington Bullets, December 30, 1994

San Antonio Spurs vs. New York Knicks, October 18, 1994

San Antonio Spurs vs. Denver Nuggets, January 28, 1995

San Antonio Spurs vs. Denver Nuggets, May 2, 1995

Los Angeles Lakers vs. San Antonio Spurs, May 8, 1995

Los Angeles Lakers vs. San Antonio Spurs, May 14, 1995

Los Angeles Lakers vs. San Antonio Spurs, May 16, 1995

San Antonio Spurs vs. Houston Rockets, June 1, 1995

Chicago Bulls vs. Cleveland Cavaliers, October 13, 1995

Chicago Bulls vs. Washington Bullets, October 17, 1995

Charlotte Hornets vs. Chicago Bulls, November 3, 1995

New York Knicks vs. Chicago Bulls, December 6, 1995

Seattle SuperSonics vs. Chicago Bulls, January 10, 1996

Chicago Bulls vs. Boston Celtics, March 2, 1996

Miami Heat vs. Chicago Bulls, April 2, 1996

Chicago Bulls vs. Orlando Magic, April 7, 1996

Charlotte Hornets vs. Chicago Bulls, April 8, 1996

New Jersey Nets vs. Chicago Bulls, April 11, 1996

Chicago Bulls vs. Milwaukee Bucks, April 16, 1996

Indiana Pacers vs. Chicago Bulls, April 20, 1996

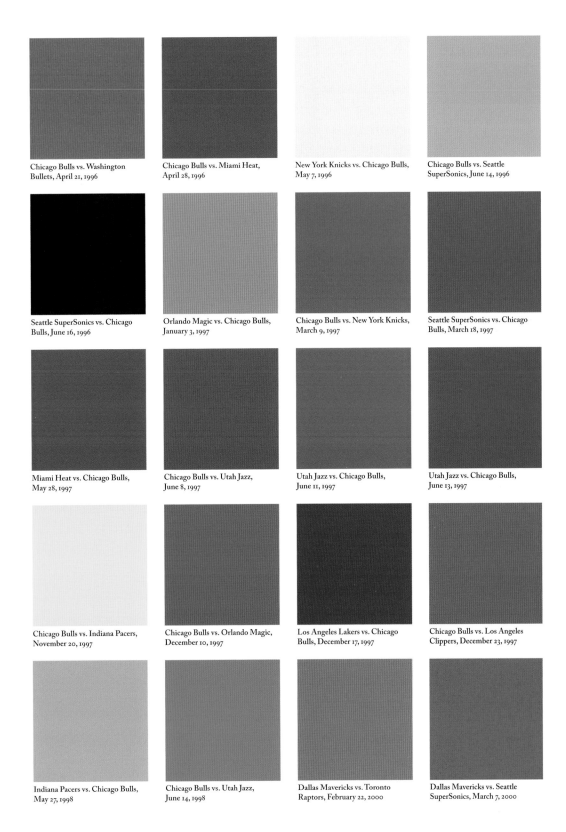

Chicago Bulls vs. Washington
Bullets, April 21, 1996

Chicago Bulls vs. Miami Heat,
April 28, 1996

New York Knicks vs. Chicago Bulls,
May 7, 1996

Chicago Bulls vs. Seattle
SuperSonics, June 14, 1996

Seattle SuperSonics vs. Chicago
Bulls, June 16, 1996

Orlando Magic vs. Chicago Bulls,
January 3, 1997

Chicago Bulls vs. New York Knicks,
March 9, 1997

Seattle SuperSonics vs. Chicago
Bulls, March 18, 1997

Miami Heat vs. Chicago Bulls,
May 28, 1997

Chicago Bulls vs. Utah Jazz,
June 8, 1997

Utah Jazz vs. Chicago Bulls,
June 11, 1997

Utah Jazz vs. Chicago Bulls,
June 13, 1997

Chicago Bulls vs. Indiana Pacers,
November 20, 1997

Chicago Bulls vs. Orlando Magic,
December 10, 1997

Los Angeles Lakers vs. Chicago
Bulls, December 17, 1997

Chicago Bulls vs. Los Angeles
Clippers, December 23, 1997

Indiana Pacers vs. Chicago Bulls,
May 27, 1998

Chicago Bulls vs. Utah Jazz,
June 14, 1998

Dallas Mavericks vs. Toronto
Raptors, February 22, 2000

Dallas Mavericks vs. Seattle
SuperSonics, March 7, 2000

Title cards from the second season of *Saturday Night Live*, 1976–77

As an avid fan of the great American institution that is *SNL*, I became entranced by the early designs of the title cards and wondered if, when seen in aggregate, the color story might tell us something about the approach to television design in the late 1970s.

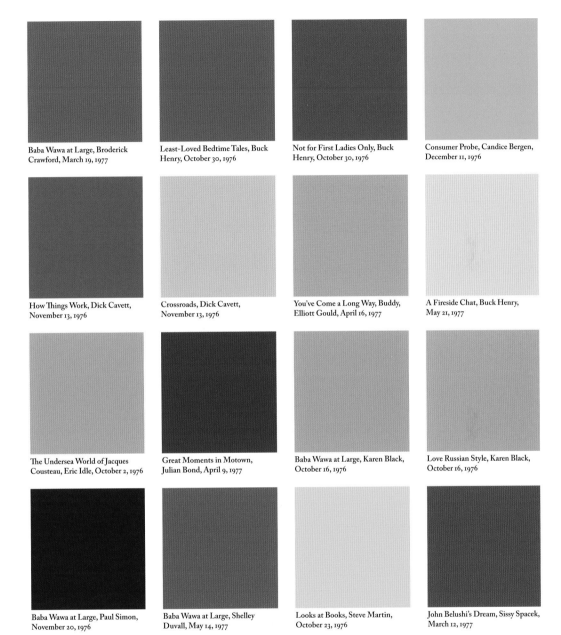

Baba Wawa at Large, Broderick Crawford, March 19, 1977

Least-Loved Bedtime Tales, Buck Henry, October 30, 1976

Not for First Ladies Only, Buck Henry, October 30, 1976

Consumer Probe, Candice Bergen, December 11, 1976

How Things Work, Dick Cavett, November 13, 1976

Crossroads, Dick Cavett, November 13, 1976

You've Come a Long Way, Buddy, Elliott Gould, April 16, 1977

A Fireside Chat, Buck Henry, May 21, 1977

The Undersea World of Jacques Cousteau, Eric Idle, October 2, 1976

Great Moments in Motown, Julian Bond, April 9, 1977

Baba Wawa at Large, Karen Black, October 16, 1976

Love Russian Style, Karen Black, October 16, 1976

Baba Wawa at Large, Paul Simon, November 20, 1976

Baba Wawa at Large, Shelley Duvall, May 14, 1977

Looks at Books, Steve Martin, October 23, 1976

John Belushi's Dream, Sissy Spacek, March 12, 1977

How Pete Davidson dresses from the waist up on Weekend Update

Consider this a sort of aura portrait of Davidson, a subject of scholarship for me. So inspired was I by the comedian's singular and sophisticated sense of color (soft wisteria purples, Denver Nuggets blues, and hot flamingo pinks), I once dressed like him for a week.

Season 42, Melissa McCarthy,
May 13, 2017

Season 42, Seth Meyers,
August 24, 2017

Season 43, Gal Gadot,
October 7, 2017

Season 43, Chance the Rapper,
November 18, 2017

Season 43, Bill Hader,
March 17, 2018

Season 43, Donald Glover,
May 5, 2018

Season 44, Adam Driver,
September 29, 2018

Season 44, Jonah Hill,
November 3, 2018

Season 44, Liev Schreiber,
November 10, 2018

Season 44, Idris Elba,
March 9, 2019

Season 44, Emma Thompson,
May 11, 2019

Season 45, David Harbour,
October 12, 2019

Spike Lee's eyeglasses, 1989–2020

Oh, to be the eyeglasses resting on the bridge of director Spike Lee's nose.
A bespectacled person myself, I inventoried the admirable variety of frames
Lee wears, handy for directing films or watching the New York Knicks
play from courtside seats. A conspicuous celebrity, he's always easy to spot
whether or not you're beleaguered with myopic vision, given his penchant
for dressing in vivid color.

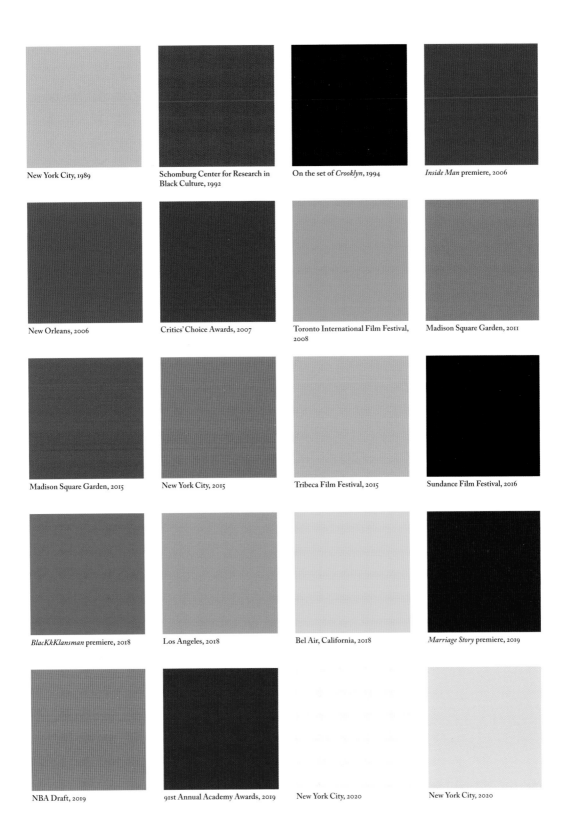

New York City, 1989

Schomburg Center for Research in Black Culture, 1992

On the set of *Crooklyn*, 1994

Inside Man premiere, 2006

New Orleans, 2006

Critics' Choice Awards, 2007

Toronto International Film Festival, 2008

Madison Square Garden, 2011

Madison Square Garden, 2015

New York City, 2015

Tribeca Film Festival, 2015

Sundance Film Festival, 2016

BlacKkKlansman premiere, 2018

Los Angeles, 2018

Bel Air, California, 2018

Marriage Story premiere, 2019

NBA Draft, 2019

91st Annual Academy Awards, 2019

New York City, 2020

New York City, 2020

CMYK Values

ART HISTORY

PAGE 14 **The reds of the red caps in Renaissance portraits, 1460–1535**

A Boy in a Scarlet Cap / C=16, M=100, Y=100, K=6

A Young Man in a Red Cap / C=30, M=90, Y=84, K=33

An Old Man and His Grandson / C=24, M=100, Y=100, K=20

Portrait of a Young Man / C=12, M=100, Y=100, K=3

Portrait of a Youth / C=20, M=100, Y=100, K=12

Portrait of a Man in a Red Cap / C=30, M=89, Y=95, K=34

Portrait of a Young Man / C=24, M=76, Y=96, K=15

Portrait of a Young Man, Bust Length, in a Red Cap / C=30, M=92, Y=90, K=34

Portrait of a Woman with Red Cap / C=0, M=95, Y=100, K=0

Portrait of Dr. Johannes Cuspinian / C=14, M=84, Y=71, K=3

Portrait of a Young Man / C=18, M=86, Y=100, K=7

Self Portrait / C=7, M=97, Y=100, K=0

Portrait of a Young Man / C=30, M=85, Y=85, K=30

Portrait of a Young Man in a Red Cap / C=17, M=91, Y=100, K=7

Portrait of Tommaso Inghirami / C=19, M=88, Y=82, K=8

Young Man in a Red Cap / C=26, M=74, Y=72, K=14

The Duke and Duchess of Urbino / C=20, M=87, Y=96, K=10

Portrait of Francesco Sforza / C=19, M=91, Y=100, K=9

Portrait of a Man in a Red Cap / C=38, M=91, Y=90, K=62

Portrait of an Unknown Man with Red Beret / C=31, M=92, Y=90, K=41

PAGE 20 **The blush of Madame de Pompadour's cheeks, 1746–63**

Portrait of Madame de Pompadour / C=11, M=27, Y=33, K=0

Portrait of Madame de Pompadour with a Fur Muff / C=25, M=41, Y=38, K=0

Portrait de Jeanne-Antoinette, Madame Pompadour / C=5, M=17, Y=19, K=0

Madame de Pompadour as Diane the Huntress / C=16, M=55, Y=63, K=0

Jeanne-Antoinette Poisson, Marquise de Pompadour / C=11, M=31, Y=27, K=0

Madame de Pompadour / C=19, M=44, Y=54, K=0

Madame de Pompadour at Her Dressing Table / C=27, M=45, Y=55, K=3

Madame de Pompadour at Her Tambour Frame / C=23, M=54, Y=33, K=0

Marquise de Pompadour / C=7, M=29, Y=36, K=0

Presumed Portrait of Madame de Pompadour / C=8, M=31, Y=31, K=0

Portrait of Jeanne-Antoinette Poisson, Madame de Pompadour / C=3, M=33, Y=34, K=0

Portrait of Madame de Pompadour as Diana / C=19, M=49, Y=57, K=0

The Marquise de Pompadour / C=23, M=68, Y=76, K=9

Portrait of the Marquise de Pompadour / C=26, M=33, Y=33, K=0

A Portrait of the Marquise de Pompadour / C=24, M=55, Y=69, K=5

Portrait of the Marquise de Pompadour / C=21, M=50, Y=50, K=0

PAGE 30 **The dresses worn by Velázquez's infantas**

Infanta Margarita Teresa in a Blue Dress, 1659 / C=80, M=60, Y=40, K=20

Infanta Margarita Teresa in a Pink Dress, 1660 / C=11, M=61, Y=62, K=0

Portrait of the Infanta María Theresa of Spain, 1651–53 / C=19, M=14, Y=11, K=0

María Teresa, Infanta of Spain, 1651–54 / C=34, M=63, Y=100, K=25

La infanta Margarita, 1653 / C=20, M=55, Y=87, K=4

La infanta Margarita, 1656 / C=32, M=26, Y=39, K=0

La infanta María Teresa, 1648 / C=23, M=26, Y=36, K=0

Las Meninas, 1656 / C=15, M=18, Y=33, K=0

PAGE 34 **Frans Hals's ruff collars**

Anna van der Aar, 1626 / C=30, M=34, Y=43, K=0

Portrait of an Elderly Man, Heer Bodolphe, 1643 / C=12, M=6, Y=9, K=0

Portrait of an Old Woman, 1633 / C=6, M=5, Y=7, K=0

Portrait of a Couple, 1622 / C=20, M=17, Y=25, K=0

Portrait of a Gentleman, Aged 37, 1637 / C=15, M=12, Y=28, K=0

Portrait of a Lady, Aged 36, 1637 / C=8, M=7, Y=18, K=0

Portrait of a Lady, 1627 / C=16, M=11, Y=13, K=0

Portrait of a Man in His Thirties, 1633 / C=7, M=7, Y=19, K=0

Portrait of a Woman (Marie Larp?), 1635–38 / C=36, M=29, Y=33, K=0

Portrait of a Woman in a White Ruff, 1640 / C=36, M=29, Y=39, K=0

Portrait of a Woman, 1635 / C=10, M=8, Y=16, K=0

Portrait of a Woman, Probably Aeltje Dircksdr. Pater, 1638 / C=21, M=17, Y=27, K=0

Portrait of an Elderly Lady, 1633 / C=8, M=7, Y=19, K=0

Portrait of an Elderly Man, 1627–30 / C=21, M=18, Y=28, K=0

Catharina Hooft and Her Nurse, 1620 / C=24, M=22, Y=17, K=0

Portrait of Mrs. Bodolphe, 1643 / C=6, M=6, Y=8, K=0

PAGE 40 **The pupils of the eyes in Vermeer's portraits, 1656–72**

Allegory of the Catholic Faith / C=64, M=64, Y=76, K=78

A Lady Writing / C=64, M=59, Y=73, K=61

A Young Woman Seated at a Virginal / C=66, M=64, Y=73, K=76

Girl with a Flute / C=68, M=61, Y=75, K=78

Girl with a Pearl Earring / C=61, M=71, Y=73, K=83

Girl with the Red Hat / C=69, M=64, Y=69, K=77

Woman with a Lute / C=60, M=62, Y=73, K=64

Young Woman Seated at a Virginal / C=72, M=66, Y=65, K=73

Officer and Laughing Girl / C=72, M=66, Y=65, K=73

Young Woman with a Pearl Necklace / C=51, M=65, Y=75, K=58

The Guitar Player / C=56, M=63, Y=75, K=61

The Milkmaid / C=67, M=68, Y=70, K=83

The Procuress / C=64, M=67, Y=73, K=81

Girl Interrupted at Her Music / C=60, M=58, Y=74, K=52

Study of a Young Woman / C=58, M=69, Y=76, K=78

Woman with a Water Jug / C=58, M=64, Y=58, K=41

PAGE 42 **Caravaggio's** *Boy with a Basket of Fruit*, **1593**

White grapes / C=32, M=29, Y=56, K=0

Peach / C=7, M=12, Y=66, K=0

Black grapes / C=79, M=81, Y=49, K=58

Medlars / C=23, M=70, Y=100, K=11

Medlars / C=51, M=65, Y=64, K=41

Pomegranate seeds / C=0, M=91, Y=91, K=0

Pear / C=23, M=22, Y=82, K=0

Grape leaf / C=61, M=48, Y=73, K=33

Pomegranate / C=42, M=37, Y=99, K=11

Striped apple / C=14, M=52, Y=85, K=0

Unripe fig / C=37, M=28, Y=80, K=3

Red grapes / C=31, M=100, Y=97, K=41

PAGE 44 **The yellow bills in John James Audubon's**
The Birds of America, 1827–38

Plate 281, Great White Heron / C=8, M=23, Y=89, K=0

Plate 108, Fox-Coloured Sparrow / C=4, M=4, Y=56, K=0

Plate 431, American Flamingo / C=0, M=4, Y=31, K=0

Plate 211, Great Blue Heron / C=3, M=3, Y=60, K=0

Plate 217, Louisiana Heron / C=3, M=6, Y=41, K=0

Plate 221, Mallard Duck / C=0, M=8, Y=71, K=0

Plate 224, Kittiwake Gull / C=3, M=3, Y=62, K=0

Plate 242, Snowy Heron, or White Egret / C=3, M=4, Y=79, K=0

Plate 71, Winter Hawk / C=6, M=17, Y=79, K=0

Plate 262, Tropic Bird / C=3, M=7, Y=50, K=0

Plate 75, Le Petit Caporal / C=0, M=15, Y=77, K=0

Plate 386, Great White Heron / C=0, M=16, Y=86, K=0

Plate 106, Black Vulture / C=3, M=4, Y=31, K=0

Plate 305, Purple Gallinule / C=4, M=11, Y=82, K=0

Plate 31, White-Headed Eagle / C=4, M=9, Y=62, K=0

Plate 427, White-Legged Oyster Catcher / C=8, M=22, Y=78, K=0

Plate 316, Black-Bellied Darter / C=3, M=0, Y=46, K=0

Plate 321, Roseate Spoonbill / C=4, M=0, Y=56, K=0

Plate 351, Great Cinereous Owl / C=3, M=0, Y=34, K=0

Plate 386, White Heron / C=3, M=3, Y=71, K=0

PAGE 46 **The blue bills in John James Audubon's**
The Birds of America, 1827–38

Plate 105, Red-Breasted Nuthatch / C=19, M=0, Y=5, K=0

Plate 12, Baltimore Oriole / C=41, M=12, Y=0, K=0

Plate 181, Golden Eagle / C=35, M=18, Y=24, K=0

Plate 222, White Ibis / C=42, M=17, Y=23, K=0

Plate 213, Puffin / C=30, M=10, Y=9, K=0

Plate 229, Scaup Duck / C=23, M=10, Y=12, K=0

Plate 299, Dusky Petrel / C=13, M=1, Y=2, K=0

Plate 307, Blue Crane, or Heron / C=33, M=29, Y=10, K=0

Plate 273, Cayenne Tern / C=22, M=20, Y=10, K=0

Plate 343, Ruddy Duck / C=11, M=3, Y=3, K=0

Plate 345, American Widgeon / C=53, M=27, Y=10, K=0

Plate 384, Black-Throated Bunting / C=28, M=8, Y=16, K=0

Plate 42, Orchard Oriole / C=43, M=14, Y=6, K=0

Plate 91, Broad-Winged Hawk / C=50, M=14, Y=8, K=0

Plate 72, Swallow-Tailed Hawk / C=31, M=15, Y=7, K=0

Plate 56, Red-Shouldered Hawk / C=25, M=3, Y=3, K=0

PAGE 48 **The roseate bills in John James Audubon's**
The Birds of America, 1827–38

Plate 162, Zenaida Dove / C=7, M=68, Y=42, K=0

Plate 167, Key West Dove / C=4, M=99, Y=98, K=0

Plate 206, Summer or Wood Duck / C=6, M=91, Y=76, K=0

Plate 222, White Ibis / C=3, M=61, Y=40, K=0

Plate 249, Tufted Auk / C=3, M=53, Y=32, K=0

Plate 251, Brown Pelican / C=11, M=62, Y=59, K=0

Plate 250, Arctic Tern / C=0, M=84, Y=84, K=0

Plate 256, Purple Heron / C=3, M=18, Y=26, K=0

Plate 273, Cayenne Tern / C=13, M=94, Y=74, K=3

Plate 276, King Duck / C=0, M=59, Y=63, K=0

Plate 427, Slender-Billed Oyster Catcher / C=17, M=100, Y=76, K=6

Plate 309, Great Tern / C=15, M=99, Y=100, K=5

Plate 314, Black-Headed Gull / C=3, M=46, Y=25, K=0

Plate 323, Black Skimmer, or Shearwater / C=22, M=100, Y=63, K=9

Plate 331, Goosander / C=0, M=73, Y=53, K=0

Plate 381, Snow Goose / C=5, M=92, Y=82, K=0

Plate 397, Scarlet Ibis / C=0, M=24, Y=16, K=0

Plate 401, Red-Breasted Merganser / C=0, M=92, Y=80, K=0

Plate 431, American Flamingo / C=15, M=100, Y=81, K=4

Plate 240, Roseate Tern / C=0, M=59, Y=49, K=0

PAGE 50 **The blush of Marie Antoinette's cheeks**

Archduchess Marie Antoinette of Austria, 1762 / C=10, M=23, Y=32, K=0

Queen Marie-Antoinette in Hunting Attire, 1771 / C=3, M=25, Y=33, K=0

Portrait of Queen Marie Antoinette of France, 1775 / C=20, M=48, Y=26, K=0

Marie-Antoinette, Queen of France, 1788 / C=11, M=19, Y=26, K=0

Marie Antoinette in a Court Dress, 1778 / C=13, M=33, Y=29, K=0

Marie-Antoinette in Front of the Temple of Love, 1780 / C=21, M=43, Y=50, K=0

Marie Antoinette with the Rose, 1783 / C=11, M=26, Y=12, K=0

Marie-Antoinette, Queen of France, Riding, 1783 / C=17, M=26, Y=41, K=0

Marie Antoinette in a Chemise Dress, 1783 / C=0, M=30, Y=35, K=0

Marie Antoinette, Queen of France and Navarre, 1787 / C=11, M=23, Y=44, K=0

Marie Antoinette, Queen of France, in Coronation Robes, 1775 / C=7, M=37, Y=25, K=0

Portrait of Marie Antoinette, Bust Length, 1800 / C=26, M=54, Y=60, K=5

PAGE 52 **Thanksgiving in America, 1825–2009**

Wattle, Wild Turkey, John James Audubon, 1825 / C=31, M=76, Y=65, K=21

Pie Halo, Boy Watching Grandmother Trim Pie, J.C. Leyendecker, 1908 /
C=0, M=46, Y=89, K=0

Reg's Socks, Cousin Reginald Catches the Thanksgiving Turkey, Norman Rockwell, 1917 /
C=16, M=100, Y=84, K=6

Baby Bonnet, Thanksgiving at Plymouth, Jennie Augusta Brownscombe, 1925 /
C=23, M=95, Y=100, K=17

Pink Floral Dress, Thanksgiving, Doris Lee, 1935 / C=10, M=43, Y=37, K=0

Celery, Freedom from Want, Norman Rockwell, 1943 / C=16, M=0, Y=43, K=0

Pickles, Freedom from Want, Norman Rockwell, 1943 / C=67, M=44, Y=88, K=35

Turkey, Catching the Thanksgiving Turkey, Grandma Moses, 1944 / C=11, M=27, Y=23, K=0

Turkey Pie, Turkey Shopping Bag, Roy Lichtenstein, 1964 / C=7, M=13, Y=84, K=0

Rose in Flower Arrangement, Thanksgiving, John Currin, 2003 / C=10, M=33, Y=30, K=0

Decorative Gourd, Harvest Display, Wayne Thiebaud, 2008 / C=19, M=82, Y=100, K=9

Pumpkin Filling, Pumpkin Cloud, Wayne Thiebaud, 2009 / C=10, M=32, Y=80, K=0

PAGE 54 **Seascapes, arranged along one horizon line**

Splash, John Wesley, 1979 / C=51, M=26, Y=0, K=0

Cape Split, Maine, John Marin, 1945 / C=77, M=42, Y=54, K=19

Kissing the Moon, Winslow Homer, 1904 / C=63, M=43, Y=56, K=17

Pink Island, White Waves, Milton Avery, 1959 / C=20, M=11, Y=18, K=0

Approach of Rain, George Bellows, 1913 / C=74, M=24, Y=58, K=5

Wave, Night, Georgia O'Keeffe, 1928 / C=83, M=69, Y=41, K=27

Sea Grasses and Blue Sea, Milton Avery, 1958 / C=89, M=77, Y=7, K=0

Penobscot, Alex Katz, 1999 / C=60, M=39, Y=27, K=3

Rough Seas near Lobster Point, Robert Henri, 1903 / C=43, M=19, Y=29, K=0

Grey Sea, John Marin, 1938 / C=49, M=32, Y=27, K=0

Eight Bells, Winslow Homer, 1886 / C=65, M=41, Y=64, K=20

Untitled, Alex Katz, 1960 / C=86, M=58, Y=41, K=21

PAGE 60 **The mountaintops of the diorama paintings
in the American Museum of Natural History**

Alaskan Moose, Hall of North American Mammals / C=17, M=27, Y=17, K=0

Bighorn Sheep, Hall of North American Mammals / C=23, M=13, Y=0, K=0

Black Rhinoceros, Hall of African Mammals / C=19, M=0, Y=3, K=0

Dall Sheep, Hall of North American Mammals / C=14, M=12, Y=0, K=0

Gorilla, Hall of African Mammals / C=33, M=28, Y=4, K=0

Grant Caribou, Hall of North American Mammals / C=37, M=24, Y=3, K=0

Northern Flying Squirrel, Hall of North American Mammals / C=40, M=7, Y=0, K=0

Northern Elephant Seal, Milstein Hall of Ocean Life / C=32, M=8, Y=0, K=0

Alaska Brown Bear, Hall of North American Mammals / C=38, M=47, Y=0, K=0

Mountain Goat, Hall of North American Mammals / C=42, M=17, Y=11, K=0

Musk Ox, Hall of North American Mammals / C=25, M=20, Y=3, K=0

American Bison and Pronghorn, Hall of North American Mammals / C=40, M=34, Y=8, K=0

Water Hole, Hall of African Mammals / C=53, M=46, Y=0, K=0

Ostrich, Hall of African Mammals / C=28, M=19, Y=0, K=0

Wapiti, Hall of North American Mammals / C=27, M=31, Y=10, K=0

Osborn Caribou, Hall of North American Mammals / C=50, M=44, Y=0, K=0

PAGE 62　　**Helen Frankenthaler's orange color fields**

Burnt Orange Roof, 1961 / C=22, M=94, Y=100, K=14

Untitled, 1961 / C=18, M=69, Y=95, K=5

Dawn Shapes, 1963 / C=13, M=41, Y=79, K=0

Only Orange, 1963 / C=16, M=60, Y=100, K=3

Saturn, 1963 / C=7, M=40, Y=89, K=0

Untitled (Helen), circa 1963 / C=12, M=60, Y=93, K=0

Untitled, 1963 / C=20, M=75, Y=96, K=9

Orange Mood, 1966 / C=9, M=77, Y=100, K=0

Orange Lozenge, 1967 / C=11, M=89, Y=100, K=3

Spices, 1968 / C=0, M=62, Y=100, K=0

Orange Downpour, 1970 / C=3, M=38, Y=75, K=0

Crusades, 1976 / C=0, M=66, Y=100, K=0

PAGE 64　　**Charles Burchfield's violets and violas**

The Violet, 1959 / C=50, M=45, Y=21, K=0

Violets, 1917 / C=37, M=43, Y=13, K=0

White Violets under Pine Bough, 1952 / C=18, M=34, Y=3, K=0

The Woodpecker, 1955–63 / C=60, M=60, Y=4, K=0

White Violets and Abandoned Coal Mine, 1918 / C=4, M=0, Y=3, K=0

PAGE 66　　**The stripes in Alice Neel's portraits**

Connie, circa 1945 / C=22, M=96, Y=78, K=13

Abe's Grandchildren, 1964 / C=71, M=60, Y=43, K=23

Hartley and Ginny, 1970 / C=16, M=18, Y=97, K=0

Benny and Mary Ellen Andrews, 1972 / C=25, M=69, Y=40, K=3

Faith Ringgold, 1977 / C=91, M=77, Y=27, K=11

Horace Clayton, 1949 / C=69, M=53, Y=81, K=57

Georgie Arce No. 2, 1955 / C=78, M=45, Y=36, K=8

Ginny in Striped Shirt, 1969 / C=96, M=86, Y=42, K=40

Hartley with a Cat, 1969 / C=100, M=98, Y=24, K=11

Isabetta, 1934–35 / C=24, M=97, Y=91, K=19

Jackie Curtis and Rita Red, 1970 / C=44, M=30, Y=91, K=6

Man with Pipe (John Rothschild), 1979 / C=22, M=78, Y=82, K=11

Portrait of Girl in Blue Chair, 1970 / C=87, M=68, Y=19, K=4

Portrait of Sari Dienes, 1976 / C=67, M=58, Y=36, K=13

Richard Gibbs, 1968 / C=0, M=80, Y=100, K=0

Untitled, 1974 / C=84, M=67, Y=28, K=10

Portrait of Sarah Elizabeth Hewitt, Niece of Lida Moser, 1966 /
C=71, M=33, Y=84, K=19

The Family, 1982 / C=78, M=45, Y=36, K=8

Georgie Arce No. 2, 1955 / C=82, M=71, Y=53, K=54

Self Portrait, 1980 / C=89, M=81, Y=0, K=0

PAGE 68 **The flesh tones of Lucian Freud's ex-wives**
Girl with a Kitten, 1947 / C=10, M=13, Y=28, K=0
Girl with Roses, 1947 / C=6, M=13, Y=18, K=0
Girl with Leaves, 1948 / C=9, M=10, Y=9, K=0
Girl in a Dark Jacket, 1947 / C=12, M=9, Y=27, K=0
Girl with a White Dog, 1950 / C=16, M=19, Y=24, K=0
Portrait of Kitty, 1948 / C=27, M=40, Y=51, K=0
Girl in Bed, 1952 / C=32, M=47, Y=86, K=10
Girl Reading, 1952 / C=29, M=47, Y=100, K=8
Hotel Bedroom, 1954 / C=6, M=8, Y=19, K=0
Girl in a Green Dress, 1954 / C=26, M=24, Y=48, K=0
Girl by the Sea, 1956 / C=8, M=29, Y=50, K=0
The Sisters, 1950 / C=22, M=32, Y=61, K=0

PAGE 70 **Fairfield Porter's skies**
Calm Morning, 1961 / C=28, M=21, Y=26, K=0
Cove Bridge, 1965 / C=21, M=10, Y=19, K=0
Daffodils and Pear Tree, 1973 / C=16, M=12, Y=7, K=0
Farmscape, 1966 / C=35, M=23, Y=25, K=0
Girl in a Landscape, 1965 / C=58, M=24, Y=45, K=0
Islands, 1968 / C=30, M=24, Y=37, K=0
Morning Sky, 1972 / C=11, M=9, Y=16, K=0
Steep Bank Beach, 1972 / C=22, M=9, Y=21, K=0
Trees in Bloom, 1968 / C=10, M=0, Y=9, K=0
Under the Elm, 1971 / C=30, M=20, Y=37, K=0
View from Bear Island, 1968 / C=18, M=0, Y=4, K=0
The First of May, 1960 / C=36, M=27, Y=27, K=0

CONTEMPORARY ART

PAGE 82 **The artist's palette, from Anguissola to Botero**
William Hogarth, 1757–58 / C=14, M=14, Y=28, K=0
Fernando Botero, 1973 / C=15, M=77, Y=96, K=3
Sofonisba Anguissola, 1556–57 / C=12, M=88, Y=87, K=2
Florine Stettheimer, 1915 / C=21, M=29, Y=86, K=0
Fernando Botero, 2011 / C=47, M=21, Y=68, K=0
Fernando Botero, 1963 / C=92, M=82, Y=21, K=7

PAGE 84 **The blues of David Hockney's pools**
Water Pouring into Swimming Pool, Santa Monica, 1964 / C=56, M=24, Y=35, K=0
Portrait of Nick Wilder, 1966 / C=92, M=64, Y=35, K=17
Peter Getting out of Nick's Pool, 1966 / C=80, M=43, Y=10, K=0
Sunbather, 1966 / C=84, M=43, Y=0, K=0
A Bigger Splash, 1967 / C=73, M=30, Y=27, K=0
Pool and Steps, 1971 / C=38, M=12, Y=14, K=0
Portrait of an Artist (Pool with Two Figures), 1972 / C=82, M=45, Y=22, K=3
Poster for Olympische Spiele München, 1972 / C=53, M=25, Y=8, K=0

Gregory in the Pool E (Paper Pool 4), 1978 / C=58, M=25, Y=16, K=0

Steps with Shadow F (Paper Pool 2), 1978 / C=80, M=40, Y=24, K=0

A Large Diver (Paper Pool 27), 1978 / C=37, M=20, Y=0, K=0

Afternoon Swimming, 1979–80 / C=83, M=56, Y=0, K=0

Pool Made with Paper and Blue Ink for Book, 1980 / C=67, M=35, Y=6, K=0

Lithographic Water made of lines and crayon, 1980 / C=84, M=56, Y=21, K=3

My Pool and Terrace, 1983 / C=6, M=0, Y=0, K=0

California Copied From 1965 Painting in 1987, 1987 / C=100, M=83, Y=29, K=15

PAGE 86 **Botero's beverages**

The Card Players, 2011 / C=8, M=33, Y=81, K=0

Una festa (A Party), 2012 / C=0, M=81, Y=66, K=0

Couple (Woman Drinking), 1999 / C=13, M=91, Y=81, K=3

Couple with Still Life, 2013 / C=13, M=32, Y=97, K=0

Still Life with white curtain, 2013 / C=21, M=93, Y=80, K=11

Dancers, 2010 / C=17, M=51, Y=97, K=3

Kitchen Table, 2002 / C=36, M=90, Y=73, K=49

Natura morta con cipolla, 2001 / C=13, M=15, Y=92, K=0

Naturaleza muerta, 1995 / C=0, M=45, Y=96, K=0

Nudist Family, 2009 / C=24, M=93, Y=80, K=17

Picnic, 1989 / C=22, M=85, Y=80, K=11

Picnic, 2002 / C=46, M=31, Y=97, K=8

Still Life, 2003 / C=16, M=13, Y=82, K=0

Still Life with Lobster, 2002 / C=6, M=9, Y=75, K=0

Still Life with Ice Cream, 1998 / C=15, M=29, Y=24, K=0

Seated Man, 2000 / C=7, M=19, Y=87, K=0

Still Life with Bottle, 1982 / C=59, M=37, Y=94, K=20

Still Life with Fruits, 2003 / C=12, M=78, Y=33, K=0

Still Life with Orangeade, 1987 / C=6, M=30, Y=92, K=0

Still Life with Fruit, 1990 / C=28, M=13, Y=26, K=0

PAGE 88 **The paint on Kerry James Marshall's smocks**

Untitled (Painter), 2008: C=45, M=41, Y=16, K=0

Untitled (Painter), 2008: C=43, M=17, Y=45, K=0

Untitled (Painter), 2008: C=54, M=27, Y=8, K=0

Untitled (Studio), 2014: C=46, M=20, Y=31, K=0

Untitled (Studio), 2014: C=63, M=43, Y=41, K=9

Untitled (Studio), 2014: C=84, M=58, Y=49, K=31

Untitled (Painter), 2008: C=15, M=31, Y=28, K=0

Untitled (Painter), 2008: C=17, M=11, Y=11, K=0

Untitled (Painter), 2008: C=45, M=27, Y=29, K=0

PAGE 90 **The greens of the garnishes in Wayne Thiebaud's still lifes**

Hamburger Counter, 1961 / C=77, M=35, Y=96, K=25

Buffet, 1972–75 / C=68, M=24, Y=100, K=7

Cakes, 1963 / C=52, M=3, Y=81, K=0

Cakes No. 1, 1967 / C=46, M=0, Y=92, K=0

Colorful Cakes, 1990 / C=43, M=0, Y=55, K=0

Delicatessen, 1964/2010 / C=52, M=13, Y=80, K=0

Lemon Meringue Pie Slices, 1990 / C=72, M=25, Y=95, K=9

Hors d'oeuvres, 1963 / C=79, M=19, Y=100, K=5

Sandwich, 1963 / C=57, M=10, Y=88, K=0

Triangle Thins, 1971 / C=56, M=23, Y=100, K=4

Two Hamburgers, 2000 / C=76, M=33, Y=79, K=19

Appetizers (from The Physiology of Taste series), 1994 / C=62, M=0, Y=86, K=0

Double Decker, 1961 / C=67, M=31, Y=100, K=14

Glass of Wine & Olives, 2002 / C=67, M=20, Y=96, K=4

Chez Panisse Desserts Study, 1984 / C=38, M=5, Y=53, K=0

Cracker Rows, 1963 / C=63, M=10, Y=100, K=0

PAGE 92 **Etel Adnan's suns**

Equilibre, 2018 / C=14, M=79, Y=87, K=3

Le poids du monde II, 2016 / C=5, M=17, Y=84, K=0

Poids du monde V, 2018 / C=4, M=6, Y=78, K=0

Power of the Sun, 2017 / C=21, M=87, Y=84, K=10

Untitled, 2014 / C=58, M=21, Y=100, K=4

Untitled, 2014 / C=0, M=15, Y=49, K=0

Untitled, 2015 / C=20, M=100, Y=100, K=13

Untitled, 2014 / C=3, M=40, Y=71, K=0

PAGE 94 **John Currin's blondes**

Park City Grill, 2000 / C=12, M=19, Y=24, K=0

"Federal" Rachel, 2006 / C=28, M=39, Y=54, K=3

Blond Angel, 2001 / C=24, M=16, Y=32, K=0

Big Hands, 2010 / C=10, M=22, Y=51, K=0

Constance Towers, 2009 / C=27, M=50, Y=100, K=8

Flora, 2010 / C=23, M=26, Y=45, K=0

Pushkin Girl, 2007 / C=17, M=22, Y=29, K=0

Happy House Painters, 2016 / C=37, M=30, Y=41, K=0

Tapestry, 2013 / C=16, M=18, Y=28, K=0

Lynette & Janette, 2013 / C=10, M=14, Y=30, K=0

Rachel in Fur, 2002 / C=23, M=32, Y=74, K=0

Nice 'n Easy, 1999 / C=27, M=31, Y=61, K=0

Nude in a Convex Mirror, 2015 / C=28, M=40, Y=73, K=4

The Dogwood Thieves, 2010 / C=15, M=16, Y=38, K=0

Lake Place, 2012 / C=22, M=25, Y=32, K=0

Rippowam, 2006 / C=16, M=17, Y=53, K=0

Stamford after Brunch, 2000 / C=16, M=29, Y=68, K=0

Thanksgiving, 2003 / C=11, M=14, Y=25, K=0

The Scream, 2010 / C=11, M=11, Y=31, K=0

Girl in Bed, 1993 / C=33, M=46, Y=100, K=11

PAGE 96 **The letter "E" in Mel Bochner's paintings**

"Observe," If the Color Changes, 2001 / C=31, M=61, Y=50, K=7

"Iciness," Indifference, 2003 / C=49, M=13, Y=100, K=0

"Cheesy," Vulgar, 2004 / C=75, M=24, Y=32, K=0

"Cipher," Nothing/Nothing, 2006 / C=25, M=12, Y=14, K=0

"Debauched," Obscene/Money, 2006 / C=28, M=6, Y=0, K=0

"Cheddar," Money, 2007 / C=78, M=23, Y=10, K=0

"Scoundrel," Scoundrel, 2010 / C=7, M=28, Y=23, K=0

"Sleazebag," Scoundrel, 2011 / C=13, M=44, Y=6, K=0

"Killer!," Amazing, 2012 / C=3, M=84, Y=100, K=0

"Beat It!!!," Go Away, 2012 / C=73, M=29, Y=28, K=0

"Be Quiet!," Silence, 2013 / C=27, M=11, Y=13, K=0

"Use It or Lose It," All or Nothing, 2014 / C=79, M=8, Y=82, K=0

"Shekels," Money, 2015 / C=65, M=4, Y=79, K=0

"Kvetch," Kvetch, Kvetch, Kvetch, 2015 / C=83, M=69, Y=3, K=0

"Master of the Universe," Top Dog, 2018 / C=0, M=24, Y=11, K=0

"Irrelevant," Meaningless, 2019 / C=11, M=53, Y=100, K=0

POP CULTURE

PAGE 108 **Tonya Harding's figure skating costumes per competition**

1991 US Figure Skating Championships, Minneapolis / C=42, M=0, Y=20, K=0

1991 World Championships, Original Program, Munich / C=8, M=21, Y=100, K=0

1991 World Championships, Munich / C=79, M=12, Y=62, K=0

1991 Skate America, Oakland / C=7, M=37, Y=0, K=0

1992 US Figure Skating Championships, Orlando / C=64, M=17, Y=64, K=0

1992 Winter Olympics, Practice, Albertville / C=55, M=13, Y=100, K=0

1992 Winter Olympics, Free Skate, Albertville / C=13, M=4, Y=8, K=0

1994, practice, Portland / C=15, M=95, Y=87, K=4

1994 US Figure Skating Championships, Detroit / C=84, M=85, Y=11, K=0

1994 Winter Olympics, Warm-Up, Lillehammer / C=14, M=91, Y=13, K=0

1994 Winter Olympics, Short Program, Lillehammer / C=0, M=89, Y=77, K=0

1994 Winter Olympics, Free Skate, Lillehammer / C=30, M=98, Y=56, K=19

PAGE 110 **Prince's concert outfits**

Dirty Mind Tour, Ritz Club, 1981 / C=46, M=37, Y=0, K=0

Purple Rain Tour, Joe Louis Arena, 1984 / C=75, M=92, Y=20, K=6

Welcome 2 America Tour, Madison Square Garden, 2010 / C=89, M=98, Y=7, K=0

Purple Rain Tour, Nassau Coliseum, 1985 / C=47, M=87, Y=33, K=11

Good Morning America Summer Concert Series, 2006 / C=72, M=13, Y=5, K=0

Act I Tour, Radio City Music Hall, 1993 / C=68, M=28, Y=0, K=0

Hit N Run-Parade Tour, Wembley Arena, 1986 / C=42, M=24, Y=0, K=0

The Nude Tour, Manchester, 1990 / C=87, M=66, Y=0, K=0

MTV Video Music Awards, 1991 / C=0, M=38, Y=86, K=0

Diamond and Pearls Tour, Earls Court, 1992 / C=3, M=15, Y=98, K=0

Act II Tour, Palais Omnisports de Paris-Bercy, 1993 / C=4, M=3, Y=85, K=0

Coachella, 2008 / C=13, M=0, Y=98, K=0

The Ultimate Live Experience Tour, Wembley Arena, 1995 / C=9, M=59, Y=0, K=0

The Ultimate Live Experience Tour, Wembley Arena, 1995 / C=7, M=31, Y=3, K=0

Love 4 One Another Charities Tour, San Jose Event Center, 1997 / C=58, M=66, Y=0, K=0

Grammys, 2004 / C=94, M=96, Y=5, K=0

PAGE 112 **Paul Thomas Anderson's oeuvre**

Amber Waves's quill on set / C=12, M=100, Y=100, K=3

Clementine's sequins / C=23, M=0, Y=5, K=0

Shasta's crochet dress / C=9, M=51, Y=100, K=0

Dirk Diggler's acceptance speech tuxedo / C=75, M=37, Y=5, K=0

Le Tigre polo on Rollergirl's former classmate / C=95, M=65, Y=37, K=20

Inherent Vice title card / C=82, M=9, Y=100, K=0

Western Buck's tie at the stereo store / C=32, M=100, Y=93, K=46

What Do Kids Know? / C=6, M=45, Y=34, K=0

Goodbye 70s...Hello 80s! / C=11, M=100, Y=21, K=0

Jeponica's paisley dress / C=19, M=27, Y=100, K=0

Petunia's receptionist dress / C=53, M=0, Y=22, K=0

Dirk Diggler's Corvette Stingray / C=7, M=80, Y=100, K=0

Postcard from Shasta aboard the Golden Fang / C=74, M=31, Y=25, K=0

Cabbage farm in Salinas / C=85, M=43, Y=74, K=38

Dr. Threeply at Chryskylodon's collar / C=53, M=9, Y=73, K=0

Amber Waves's perfume bottle / C=14, M=42, Y=21, K=0

Doc Sportello's telephone receiver / C=55, M=17, Y=59, K=0

Dirk Diggler's swim trunks / C=3, M=80, Y=100, K=0

Rollergirl's heart-shaped sunglasses / C=7, M=9, Y=73, K=0

Chick Planet Massage / C=74, M=88, Y=43, K=45

PAGE 114 **Craig Sager's suits, in chronological order over the course of his sportscasting career**

NBA All-Star Game, Los Angeles, February 20, 2011 / C=58, M=82, Y=39, K=23

Chicago Bulls vs. Miami Heat, May 24, 2011 / C=3, M=69, Y=40, K=0

Miami Heat vs. Chicago Bulls, April 12, 2012 / C=7, M=62, Y=90, K=0

Los Angeles Lakers vs. Denver Nuggets, May 6, 2012 / C=33, M=0, Y=21, K=0

Denver Nuggets vs. Los Angeles Lakers, May 8, 2012 / C=67, M=39, Y=0, K=0

NBA Draft, June 28, 2012 / C=14, M=91, Y=17, K=0

NBA All-Star Weekend, Houston, February 16, 2013 / C=69, M=1, Y=19, K=0

Oklahoma City Thunder vs. Golden State Warriors, April 11, 2013 / C=19, M=22, Y=38, K=0

Chicago Bulls vs. Miami Heat, May 6, 2013 / C=0, M=59, Y=76, K=0

Chicago Bulls vs. Miami Heat, May 8, 2013 / C=75, M=44, Y=10, K=0

Chicago Bulls vs. Miami Heat, May 15, 2013 / C=0, M=79, Y=21, K=0

Indiana Pacers vs. Miami Heat, May 22, 2013 / C=40, M=0, Y=5, K=0

Indiana Pacers vs. Miami Heat, May 30, 2013 / C=0, M=82, Y=0, K=0

Oklahoma City Thunder vs. Golden State Warriors, November 14, 2013 / C=14, M=5, Y=5, K=0

NBA All-Star Weekend, New Orleans, February 14, 2014 / C=14, M=100, Y=92, K=4

Oklahoma City Thunder vs. Chicago Bulls, March 5, 2015 / C=13, M=95, Y=100, K=3

New Orleans Pelicans vs. Golden State Warriors, October 27, 2015 / C=0, M=80, Y=100, K=0

Boston Celtics vs. Atlanta Hawks, November 24, 2015 / C=0, M=91, Y=76, K=0

NBA All-Star Weekend, Toronto, February 13, 2016 / C=78, M=60, Y=0, K=0

NBA All-Star Practice, Toronto, February 13, 2016 / C=18, M=66, Y=23, K=0

PAGE 116 **Walt Frazier's suits, in chronological order over the course of his sportscasting career**

New York Knicks vs. New Orleans Hornets, March 27, 2009 / C=77, M=64, Y=44, K=29

Sacramento Kings vs. New York Knicks, November 17, 2010 / C=14, M=98, Y=100, K=4

New York Knicks vs. Boston Celtics, April 23, 2013 / C=17, M=37, Y=70, K=0

New York Knicks vs. Milwaukee Bucks, October 30, 2013 / C=15, M=0, Y=5, K=0

Sacramento Kings vs. New York Knicks, March 26, 2014 / C=58, M=32, Y=42, K=3

Miami Heat vs. New York Knicks, November 23, 2015 / C=9, M=49, Y=85, K=0

NBA All-Star Game, New York, February 15, 2015 / C=23, M=88, Y=100, K=17

New York Knicks vs. New Orleans Pelicans, January 19, 2015 / C=13, M=100, Y=100, K=4

Atlanta Hawks vs. New York Knicks, December 28, 2016 / C=3, M=80, Y=72, K=0

Los Angeles Clippers vs. New York Knicks, March 11, 2016 / C=43, M=0, Y=8, K=0

New York Knicks vs. Boston Celtics, January 12, 2016 / C=0, M=80, Y=46, K=0

New York Knicks vs. Memphis Grizzlies, October 29, 2016 / C=0, M=74, Y=51, K=0

NBA Draft Lottery, May 16, 2017 / C=58, M=78, Y=18, K=3

New York Knicks vs. Washington Wizards, December 3, 2018 / C=0, M=36, Y=77, K=0

Brooklyn Nets vs. New York Knicks, December 26, 2019 / C=7, M=32, Y=26, K=0

New York Knicks vs. Detroit Pistons, April 10, 2019 / C=4, M=15, Y=13, K=0

New York Knicks vs. Los Angeles Clippers, March 24, 2019 / C=32, M=99, Y=70, K=36

New York Knicks vs. Los Angeles Lakers, March 17, 2019 / C=84, M=54, Y=60, K=44

Cleveland Cavaliers vs. New York Knicks, February 3, 2020 / C=22, M=82, Y=100, K=13

Houston Rockets vs. New York Knicks, February 24, 2020 / C=24, M=100, Y=100, K=22

PAGE 118 **Dennis Rodman's hair dye, in chronological order over the course of his NBA career**

San Antonio Spurs vs. Washington Bullets, December 30, 1994 / C=9, M=35, Y=100, K=0

San Antonio Spurs vs. New York Knicks, October 18, 1994 / C=10, M=100, Y=55, K=0

San Antonio Spurs vs. Denver Nuggets, January 28, 1995 / C=25, M=100, Y=61, K=15

San Antonio Spurs vs. Denver Nuggets, May 2, 1995 / C=25, M=100, Y=100, K=26

Los Angeles Lakers vs. San Antonio Spurs, May 8, 1995 / C=80, M=16, Y=100, K=4

Los Angeles Lakers vs. San Antonio Spurs, May 14, 1995 / C=62, M=19, Y=100, K=3

Los Angeles Lakers vs. San Antonio Spurs, May 16, 1995 / C=19, M=100, Y=100, K=10

San Antonio Spurs vs. Houston Rockets, June 1, 1995 / C=7, M=28, Y=86, K=0

Chicago Bulls vs. Cleveland Cavaliers, October 13, 1995 / C=21, M=100, Y=100, K=12

Chicago Bulls vs. Washington Bullets, October 17, 1995 / C=29, M=37, Y=71, K=3

Charlotte Hornets vs. Chicago Bulls, November 3, 1995 / C=6, M=17, Y=88, K=0

New York Knicks vs. Chicago Bulls, December 6, 1995 / C=83, M=17, Y=84, K=3

Seattle SuperSonics vs. Chicago Bulls, January 10, 1996 / C=0, M=4, Y=4, K=0

Chicago Bulls vs. Boston Celtics, March 2, 1996 / C=8, M=29, Y=86, K=0

Miami Heat vs. Chicago Bulls, April 2, 1996 / C=7, M=96, Y=86, K=0

Chicago Bulls vs. Orlando Magic, April 7, 1996 / C=18, M=100, Y=91, K=9

Charlotte Hornets vs. Chicago Bulls, April 8, 1996 / C=14, M=100, Y=80, K=3

New Jersey Nets vs. Chicago Bulls, April 11, 1996 / C=0, M=77, Y=22, K=0

Chicago Bulls vs. Milwaukee Bucks, April 16, 1996 / C=21, M=82, Y=71, K=9

Indiana Pacers vs. Chicago Bulls, April 20, 1996 / C=9, M=57, Y=88, K=0

PAGE 118 **Dennis Rodman's hair dye, in chronological order over the course of his NBA career**

Chicago Bulls vs. Washington Bullets, April 21, 1996 / C=0, M=94, Y=93, K=0

Chicago Bulls vs. Miami Heat, April 28, 1996 / C=14, M=97, Y=100, K=4

New York Knicks vs. Chicago Bulls, May 7, 1996 / C=7, M=6, Y=13, K=0

Chicago Bulls vs. Seattle SuperSonics, June 14, 1996 / C=11, M=33, Y=96, K=0

Seattle SuperSonics vs. Chicago Bulls, June 16, 1996 / C=94, M=83, Y=47, K=56

Orlando Magic vs. Chicago Bulls, January 3, 1997 / C=6, M=75, Y=22, K=0

Chicago Bulls vs. New York Knicks, March 9, 1997 / C=16, M=96, Y=13, K=0

Seattle SuperSonics vs. Chicago Bulls, March 18, 1997 / C=51, M=85, Y=14, K=0

Miami Heat vs. Chicago Bulls, May 28, 1997 / C=13, M=100, Y=100, K=3

Chicago Bulls vs. Utah Jazz, June 8, 1997 / C=21, M=92, Y=60, K=6

Utah Jazz vs. Chicago Bulls, June 11, 1997 / C=4, M=100, Y=100, K=0

Utah Jazz vs. Chicago Bulls, June 13, 1997 / C=80, M=32, Y=81, K=19

Chicago Bulls vs. Indiana Pacers, November 20, 1997 / C=3, M=6, Y=57, K=0

Chicago Bulls vs. Orlando Magic, December 10, 1997 / C=9, M=88, Y=100, K=3

Los Angeles Lakers vs. Chicago Bulls, December 17, 1997 / C=24, M=95, Y=95, K=20

Chicago Bulls vs. Los Angeles Clippers, December 23, 1997 / C=19, M=80, Y=88, K=8

Indiana Pacers vs. Chicago Bulls, May 27, 1998 / C=6, M=44, Y=82, K=0

Chicago Bulls vs. Utah Jazz, June 14, 1998 / C=62, M=18, Y=100, K=3

Dallas Mavericks vs. Toronto Raptors, February 22, 2000 / C=12, M=75, Y=87, K=3

Dallas Mavericks vs. Seattle SuperSonics, March 7, 2000 / C=69, M=55, Y=19, K=3

PAGE 122 **Title cards from the second season of *Saturday Night Live*, 1976–77**

Baba Wawa at Large, Broderick Crawford, March 19, 1977 / C=22, M=92, Y=28, K=0

Least-Loved Bedtime Tales, Buck Henry, October 30, 1976 / C=79, M=23, Y=100, K=9

Not for First Ladies Only, Buck Henry, October 30, 1976 / C=15, M=96, Y=100, K=5

Consumer Probe, Candice Bergen, December 11, 1976 / C=3, M=52, Y=0, K=0

How Things Work, Dick Cavett, November 13, 1976 / C=76, M=57, Y=21, K=3

Crossroads, Dick Cavett, November 13, 1976 / C=24, M=23, Y=10, K=0

You've Come a Long Way, Buddy, Elliott Gould, April 16, 1977 / C=11, M=40, Y=82, K=0

A Fireside Chat, Buck Henry, May 21, 1977 / C=4, M=28, Y=7, K=0

The Undersea World of Jacques Cousteau, Eric Idle, October 2, 1976 / C=46, M=29, Y=0, K=0

Great Moments in Motown, Julian Bond, April 9, 1977 / C=27, M=87, Y=100, K=25

Baba Wawa at Large, Karen Black, October 16, 1976 / C=51, M=18, Y=17, K=0

Love Russian Style, Karen Black, October 16, 1976 / C=34, M=31, Y=19, K=0

Baba Wawa at Large, Paul Simon, November 20, 1976 / C=80, M=100, Y=27, K=22

Baba Wawa at Large, Shelley Duvall, May 14, 1977 / C=27, M=91, Y=0, K=0

Looks at Books, Steve Martin, October 23, 1976 / C=3, M=17, Y=78, K=0

John Belushi's Dream, Sissy Spacek, March 12, 1977 / C=25, M=77, Y=96, K=16

PAGE 124 **How Pete Davidson dresses from the waist up on Weekend Update**

Season 42, Melissa McCarthy, May 13, 2017 / C=3, M=92, Y=64, K=0

Season 42, Seth Meyers, August 24, 2017 / C=0, M=54, Y=77, K=0

Season 43, Gal Gadot, October 7, 2017 / C=3, M=34, Y=0, K=0

Season 43, Chance the Rapper, November 18, 2017 / C=58, M=84, Y=3, K=0

Season 43, Bill Hader, March 17, 2018 / C=47, M=28, Y=0, K=0

Season 43, Donald Glover, May 5, 2018 / C=54, M=0, Y=43, K=0

Season 44, Adam Driver, September 29, 2018 / C=0, M=85, Y=78, K=0

Season 44, Jonah Hill, November 3, 2018 / C=0, M=67, Y=74, K=0

Season 44, Liev Schreiber, November 10, 2018 / C=0, M=31, Y=16, K=0

Season 44, Idris Elba, March 9, 2019 / C=0, M=23, Y=85, K=0

Season 44, Emma Thompson, May 11, 2019 / C=34, M=0, Y=4, K=0

Season 45, David Harbour, October 12, 2019 / C=0, M=28, Y=0, K=0

PAGE 126 **Spike Lee's eyeglasses, 1989–2020**

New York City, 1989 / C=100, M=78, Y=21, K=0

Schomburg Center for Research in Black Culture, 1992 / C=60, M=59, Y=55, K=32

On the set of *Crooklyn*, 1994 / C=78, M=70, Y=58, K=70

Inside Man premiere, 2006 / C=23, M=93, Y=100, K=18

New Orleans, 2006 / C=24, M=82, Y=100, K=17

Critics' Choice Awards, 2007 / C=29, M=84, Y=100, K=30

Toronto International Film Festival, 2008 / C=18, M=30, Y=100, K=0

Madison Square Garden, 2011 / C=17, M=60, Y=100, K=3

Madison Square Garden, 2015 / C=15, M=99, Y=100, K=6

New York City, 2015 / C=0, M=87, Y=100, K=0

Tribeca Film Festival, 2015 / C=18, M=25, Y=56, K=0

Sundance Film Festival, 2016 / C=88, M=77, Y=55, K=70

BlacKkKlansman premiere, 2018 / C=73, M=52, Y=0, K=0

Los Angeles, 2018 / C=6, M=53, Y=100, K=0

Bel Air, California, 2018 / C=3, M=13, Y=99, K=0

Marriage Story premiere, 2019 / C=100, M=96, Y=4, K=3

NBA Draft, 2019 / C=0, M=84, Y=83, K=0

91st Annual Academy Awards, 2019 / C=60, M=97, Y=31, K=16

New York City, 2020 / C=4, M=3, Y=3, K=0

New York City, 2020 / C=22, M=0, Y=27, K=0

Acknowledgments

This book exists, all thanks to…

My parents and my grandparents, who fed, housed, and generally tolerated me while I worked on the bulk of this book in the midst of various quarantines. That was great; let's never do it again.

And those same parents, who—in addition to all that they've given me—also gave me the best thing of all: Namely, my brother William, who pipes laughter into our lives like it's water and with whom every day spent is like its own bizarre work of art.

Stephanie Holstein, the editor of this book, a great champion of the palettes, a delight to exchange hundreds of emails with over the course of a global pandemic, and a magnificent collaborator whose sense of humor carried us over the finish line.

Zachary Fine. I was somehow able to have my favorite writer pen the foreword of this book. Thank you, Zach.

Paul Wagner and Paula Baver, who designed this book so elegantly. This marks the first time a PDF took my breath away.

Sarah Bolling and Seth Fishman at the Gernert Company.

My teachers, for whom I have the utmost admiration. How lucky I was to have my young mind molded by Stephanie Curci, Chris Jones, David Fox, Tom Roberts, and Lisa Young.

The Rhode Island School of Design, the Oxbow School, and Phillips Academy Andover.

My friends who have been there along the way, in their own ways: Emerson Bruns, Haley Scott, Sydney Mondry, Maxson Jarecki, Jamie Fehrnstrom, Jake Cahan, Molly Young, Grace Pandola, Alex Kaplan, Grace Hoyt, Starling Irving, Luke Borchelt, Annie Pluimer, Samuel Hardeman, and Elizabeth McAvoy (who saved my bacon at RISD on multiple occasions, once painting a vast—and unfortunately brown—gallery white with me in one weekend).

My former colleagues, whose editorial mentorship, friendship, and tremendous generosity of spirit contributed to this project in one way or another: Mallory Rice, Tiffany Wilkinson-Raemer, Harling Ross, Haley Nahman, Nora Taylor, Emily Zirimis, Louisiana Gelpi, Leandra Medine Cohen, Amelia Diamond, Elizabeth Tamkin, Ana Tellez, Amalie MacGowan, Gyan Yankovich.

New York City.

Published by
Princeton Architectural Press
202 Warren Street
Hudson, New York 12534
www.papress.com

Editor: Stephanie Holstein
Designers: Paul Wagner, Paula Baver

Library of Congress Cataloging-in-Publication Data
Names: Young, Edith, author.
Title: Color scheme : an irreverent history of art and pop culture in color palettes / Edith Young.
Description: First edition. New York : Princeton Architectural Press, [2021]
Identifiers: LCCN 2020057934 | ISBN 9781616899929
(hardcover)
Subjects: LCSH: Color in art. | Colors—Miscellanea.
Classification: LCC ND1490.Y69 2021 | DDC 701/.85—dc23
LC record available at https://lccn.loc.gov/2020057934